The Essential Art of African Textiles

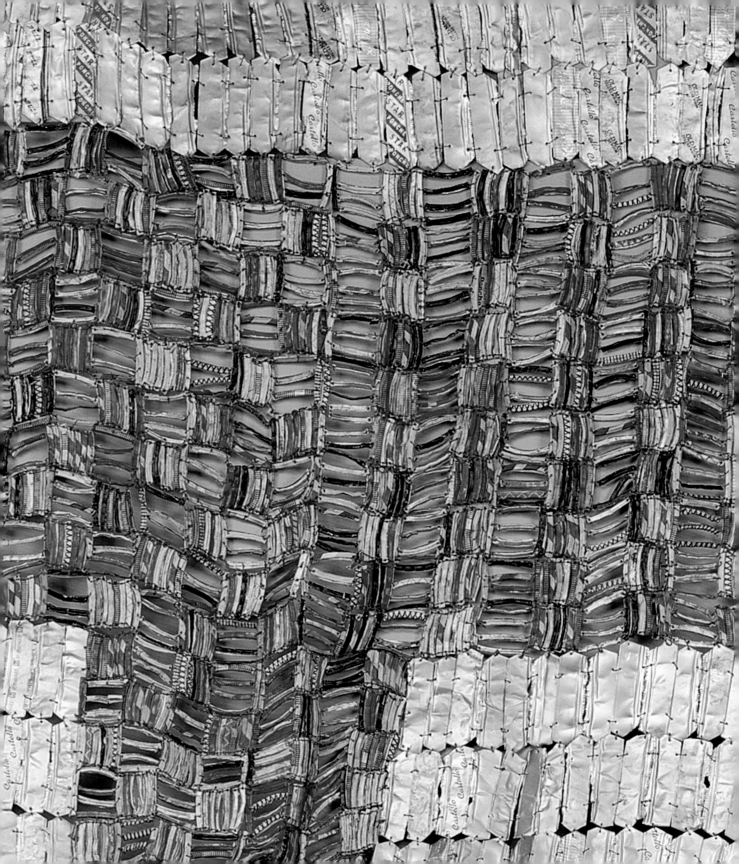

The Essential Art of African Textiles | Design Without End

Alisa LaGamma and Christine Giuntini

The Metropolitan Museum of Art, New York
Yale University Press, New Haven and London

This volume has been published in conjunction with the exhibition "The Essential Art of African Textiles: Design Without End," held at The Metropolitan Museum of Art, New York, September 30, 2008–March 22, 2009.

The exhibition is made possible in part by The Andrew W. Mellon Foundation, Fred and Rita Richman, and The Ceil & Michael E. Pulitzer Foundation, Inc.

It was organized by The Metropolitan Museum of Art, New York, in collaboration with the British Museum, London.

Published by The Metropolitan Museum of Art, New York
John P. O'Neill, *Publisher and Editor in Chief*
Ruth Lurie Kozodoy, *Senior Editor*
Antony Drobinski, *Designer*
Peter Antony and Kathryn Ansite, *Production*

New photography by Peter Zeray, The Photograph Studio, The Metropolitan Museum of Art

Typeset in Warnock; displays in Myriad
Printed on 100 lb. Creator Silk Text
Separations by Professional Graphics, Inc., Rockford, Illinois
Printed and bound by Meridian Printing, East Greenwich, Rhode Island

Jacket: Detail of a *kente* prestige cloth, 19th century (cat. no. 1)
Frontispiece: Detail of El Anatsui, *Between Earth and Heaven*, 2006 (cat. no. 16)

Library of Congress Cataloging-in-Publication Data

Metropolitan Museum of Art (New York, N.Y.)
 The essential art of African textiles : design without end / Alisa LaGamma and Christine Giuntini.
 p. cm.
 Published in conjunction with an exhibition held at the Metropolitan Museum of Art, New York, Sept. 30, 2008–Mar. 29, 2009.
 Includes bibliographical references and index.
 ISBN 978-1-58839-293-0 (Metropolitan Museum of Art : pbk.) — ISBN 978-0-300-14962-3 (Yale University Press : pbk.) 1. Textile fabrics, Black—Africa, West—Exhibitions. 2. West African strip weaving—Exhibitions. 3. Textile fabrics—New York (State)—New York—Exhibitions. 4. Metropolitan Museum of Art (New York, N.Y.)—Exhibitions. I. LaGamma, Alisa. II. Giuntini, Christine. III. Title.
 NK8989.M48 2008
 746.0966'0747471—dc22
 2008035957

Director's Foreword

In January 2008 the Metropolitan Museum put on exhibition its first acquired contemporary African sculpture, *Between Earth and Heaven* by El Anatsui. The artist himself directed its installation in the Michael C. Rockefeller Wing, which houses the arts of Africa, Oceania, and the Americas. Since then another of Anatsui's expansive creations has entered the Museum, this one joining the permanent collection of modern and contemporary art—and thus emphasizing on the international stage his standing as one of Africa's leading artists. In this catalogue and the exhibition it accompanies, *Between Earth and Heaven* is offered for consideration in the context of the rich regional and historical textile traditions it evokes. African textiles have inspired a number of other contemporary artists, whose works are also represented.

Some time ago I asked the curator of this exhibition, Alisa LaGamma, "What is so 'essential' about African textiles?" She replied that textiles are the most widespread medium of expression across sub-Saharan Africa, in addition to being an area of creativity that retains much historical continuity. This art form, which perhaps has a greater impact on peoples' everyday lives than most others, acts as both a means for individual expression and a vibrant collective social statement. Yet, in part because they are ubiquitous, textiles are often taken for granted in the West. The present exhibition provides an opportunity for us both to recognize the importance of African textiles in the canon of art history and to examine their continuing influence on contemporary art.

It is fitting that this exhibition be presented at the Metropolitan, where a number of expositions have demonstrated the artistic impetus provided by textiles, including those related to the work of Henri Matisse. The vivid colors and patterns of woven textiles were the primary source of visual stimulation in Matisse's hometown in northern France during his childhood, and they are unrivaled in their brilliance at Kumasi, the Asante urban center where El Anatsui pursued his formal studies in fine and applied arts. "The Essential Art of African Textiles: Design Without End" opens our eyes to the aesthetics of West Africa's classical textile genres as a source of inspiration to artists in Africa and beyond.

We are most grateful to The Andrew W. Mellon Foundation for its ongoing support of special exhibitions and many other endeavors here at the Metropolitan Museum, as well as to Fred and Rita Richman and The Ceil & Michael E. Pulitzer Foundation, Inc., for helping make this exhibition possible.

Philippe de Montebello
Director, The Metropolitan Museum of Art

Acknowledgments

This exhibition was developed in cooperation with the British Museum and is greatly dependent on the generous contributions of colleagues at that institution. We thank its Director, Neil MacGregor, for his support of important loans from its superb collection of historical works, and his staff for their tireless efforts and exceptional collegial collaboration. Julie Hudson, Keeper for Africa, and Helen Wolfe, Textiles Collections Manager, made their collections accessible beginning in June 2007 and were extraordinary partners who oversaw the demanding preparation of objects for presentation in New York.

This project is unusual in its juxtaposition of traditional textiles with works by contemporary artists, and we would like to thank a number of individuals for their thoughtful engagement throughout. El Anatsui put much time and effort

into the installation of *Between Earth and Heaven*, sharing with us his perspective on it. We thank October Gallery and David Krut Projects for their roles in facilitating this acquisition, and Jack Shainman Gallery for assistance in coordinating the artist's involvement. We are grateful to Grace Ndiritu for helping plan the projection of her work in our galleries, and to Christopher Noey and Jessica Glass of the Museum's Education Department, who worked with her. We thank Ninah and Michael Lynne for the loan of Yinka Shonibare's *100 Years*, and we are grateful to Ron Packman, who made it possible for Sokari Douglas Camp's *Nigerian Woman Shopping* to be included in the exhibition. Thanks to Nina Maruca, Senior Associate Registrar at the Metropolitan, works from New York, London, and Addis Ababa were deftly assembled.

Artworks in this exhibition belonging to the Metropolitan Museum are the acquisitions of several different departments. We thank our colleagues Malcolm Daniel, of Photographs, George Goldner and Samantha Rippner, of Drawings and Prints, and Virginia-Lee Webb, of the AAOA's Photograph Study Collection, for making available objects in their collections.

A vital stimulus was provided by the memorable visit to Ghana hosted by Yaw Nyarko, Director of New York University's Africa House, and by colleagues at the NYU Ghana campus, and we are grateful to them. We thank Lyle Ashton Harris for his contributions to the present endeavor. A critical basis for the project was the scholarship of Doran Ross, whose thoughtful editorial input also helped improve these texts. We appreciate the useful discussions we have had with Duncan Clarke. We are especially grateful to Dr. Pascal Imperato for ever-generously sharing his knowledge with us.

Throughout the planning and mounting of this exhibition, Yaëlle Biro's astute and thoughtful efforts were an invaluable asset. Able assistance was provided by Sandrine Colard, Lydie Diakhaté, Zoë Papademetriou, and Felicity Tsikiwa.

The challenge of designing an installation that successfully integrated a diverse range of media was brilliantly met by Daniel Kershaw. We thank Linda Sylling, Patricia Gilkison, and Rebecca Fifield for coordinating this complex effort, and Taylor Miller for its implementation. Alexandra Walcott and her staff, along with Robert Sorenson, effectively carried out the installation.

The publication of this catalogue would not have been possible without the professionalism of John O'Neill, Publisher and Editor in Chief, and his staff. Ruth Kozodoy, Senior Editor, guided the book to clarity and coherence. Its handsome design is the work of Antony Drobinski, while Peter Antony and Kathryn Ansite adeptly oversaw its production. Barbara J. DeGennaro prepared the index. The large scale of the featured textiles from our collection made photographing them a challenge, and we thank Peter Zeray of The Photograph Studio for his skillful work.

Our special thanks to The Andrew W. Mellon Foundation, Fred and Rita Richman, and Ceil and Michael E. Pulitzer for helping make this exhibition possible. We would also like to express our appreciation to William Goldstein, Holly and David Ross, Gladys and James Strain, Glenn Silverii, and Doreen and Gil Bassin, generous supporters of African art at the Metropolitan, who contributed the resources necessary for the undertaking of this publication.

From its inception the project has benefited from the support of Julie Jones, Andrall E. Pearson Curator in Charge of the Arts of Africa, Oceania, and the Americas. Finally, we thank Philippe de Montebello, Director, for providing an unfailing vision that has inspired his staff continually to expand the narrative of the history of art at the Metropolitan Museum.

Alisa LaGamma, Curator
Christine Giuntini, Conservator
Arts of Africa, Oceania, and the Americas

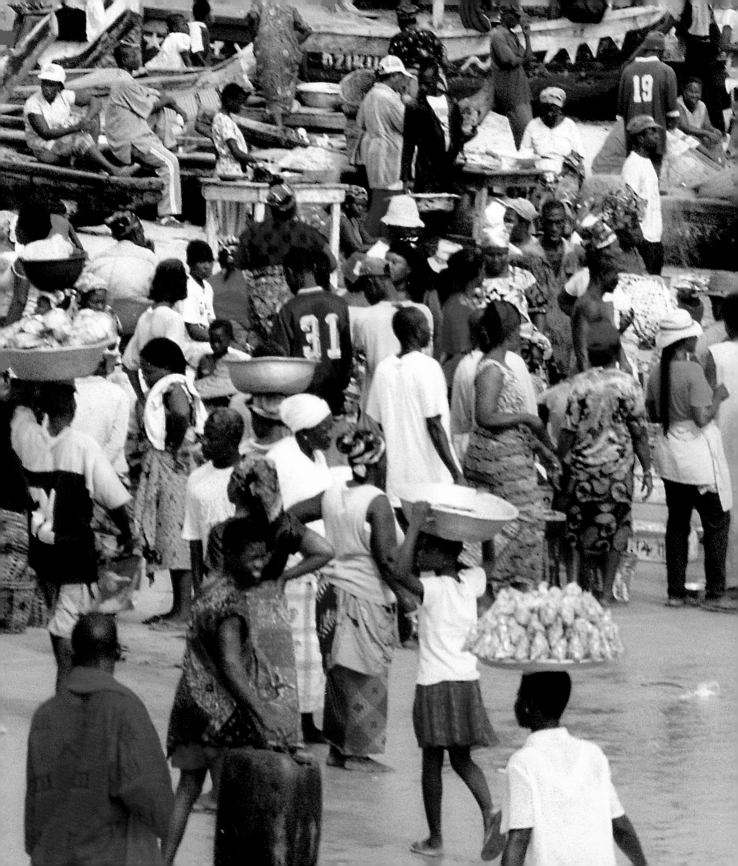

The Poetics of Cloth | Alisa LaGamma

A Human Kaleidoscope

Under the African sun the crowded streets and dynamic markets of Dakar, Bamako, Accra, and Lagos are ablaze, offering a rich collage of fabrics (fig. 1). This kaleidoscopic image is the sum of countless expressions of individual aesthetic preference, and its spectacular patterns incorporate every color in the chromatic spectrum. The textiles that animate these human panoramas are major commodities. In West Africa, marketplaces are vibrant centers of commerce and exchange for the dispersal of a never-ending array of fabrics, from locally woven, embroidered, and dyed genres of cloth to the wax-printed textiles industrially manufactured in Haarlem, Manchester, Bamako, Accra, Lagos, and, most recently, China.

Despite abundant evidence of their cultural importance, textiles have invariably been relegated to a secondary status in Western assessments of African art. Ironically, this has occurred while traditional patronage of sculpture—the African art form most valued outside Africa—has declined in most of the continent over the last century. The production of textiles, in contrast, continues to be a vital creative activity and serves a great demand across West Africa. Textiles also afford insights into the true pace of artistic change in this region of the world, which all too often is portrayed as immutable and tradition-bound yet has continually embraced innovation in the making of fabrics. This publication and the

exhibition it accompanies seek to examine the aesthetic language of West African textiles and demonstrate its profound influence on contemporary African art.

Textile design fluidly absorbs innovation and transcends cultural boundaries. Conceived as canvases that can be adapted to the human form, textiles express an aesthetic at once personal in nature and cosmopolitan in scope, and can be appreciated for both their technical and their aesthetic virtuosity. Given fashion's insatiable appetite for novel ways to enhance appearance, textiles more than any other idiom of expression have, throughout history, circulated widely and across vast distances through trade networks. Examples so obtained have in turn been adapted by far-flung consumers and have stimulated local artists to develop new designs, techniques, and materials in their own creative endeavors. This essay will explore the aesthetics of textiles in West Africa, their history, and how they permeate the continent's creative expression.

A Classical Vernacular

Some fundamental aesthetic qualities of West Africa's textile genres have proved resonant for contemporary artists. The variety and luxuriance of African textiles render them among the continent's most splendid artistic statements, and historically the medium has been especially vibrant in West Africa, the focus of this

Figure 1.
Lyle Ashton Harris (American, b. 1965), *Untitled (Jamestown #7)*, Accra, detail, 2006. Courtesy of the artist and CRG Gallery

catalogue; there is also evidence of its primacy in Central and East Africa.

In this tradition, the breadth of a piece of woven cloth was typically achieved by aligning a series of parallel bands and stitching them together to create a continuous canvas. This segmented structure favors a surface articulation with a density of pattern. The composition may consist of the elemental repetition of a single design motif, or it may juxtapose contrasting bands of design or present an even more complex application of multiple motifs. Patrick McNaughton has noted that textiles produced by the Mande culture, whether the most elemental white cottons or clothes with multicolored woven patterns or stamp-dyed configurations, are all conceived as "imbued with the precision and clarity of civilization."[1] While particular textiles may reflect different levels of complexity, they all share an underlying adherence to established parameters of visual organization. The principle of precision and clarity (*jayan*), says McNaughton, allows a focus on essential visual qualities. Graphic definition and impressive scale are critical elements of the experience of African textiles, and so is flowing movement. Employed as backdrops, spatial dividers, or voluminous garments that are draped, layered, or wrapped around the body, textiles are not rigidly two-dimensional but rather shaped by light and shadow, movement, wind, and the human form.

The history of textiles across the continent is one of vitality and innovation in which myriad distinct genres have developed and become the springboard for other designs. A formidable literature on African textiles, pioneered by Roy Sieber in a landmark 1972 Museum of Modern Art exhibition and followed by John Picton and John Mack's 1979 survey, provides a substantial foundation for appreciation of the technical and regional practices that have informed these textile traditions.[2] The examples of major textile genres cited by Picton and Mack are drawn from the incomparable collection of African textiles in the British Museum, London, which is also the source of many of the works in the present exhibition and catalogue. Many of these were collected during the nineteenth century, some by colonial officials and others by European textile industrialists, and are among the earliest examples of major textile traditions to be preserved—providing an opportunity for us to consider this form of expression in the broadest possible historical perspective. The works selected for discussion reflect certain aesthetic precepts and qualities that have endured over many generations and also demonstrate that their makers were responding to artistic inspiration from an array of sources.

Thus these textiles are material evidence of both the longstanding premium placed upon this medium of expression and the far-ranging exchanges in which their creators have been engaged. Contemporary artists have drawn on this complex cultural legacy while working beyond the textile genres, in media that include painting, sculpture, and video. The nineteenth-century textiles are part of a continuum of work by artists in ongoing traditions, and their visual language has become a point of departure for far more personalized idioms of expression.

African Textiles and Their Presence in Contemporary Art

In recent years the sculptor El Anatsui has been acclaimed internationally for the power of his complex creations, variously described as metal textiles or tapestries. These ambitious works are impressive for their scale, aesthetic impact, and originality. At the heart of this exhibition is *Between Earth and Heaven* (cat. no. 16), completed

in 2006, which has the capacity to transcend any intellectual frame of reference and captivate us on a purely visual level; it is both breathtaking and conceptually engaging. Although Anatsui should not be characterized simply as an African or Ghanaian artist, insight into the nature of his remarkable accomplishment can be gained by evoking the history and visual tradition to which he poetically alludes.

In this work Anatsui effects the translation of a familiar icon—a conceptual action on the order of Jasper Johns's appropriation of the American flag. The classic *kente* textile tradition of Asante and Ewe weavers (on *kente*, see cat. no. 1) has been subjected to a complete transformation yet is recognizable in vestigial form. The son and brother of men who wove Ewe *kente* cloth, Anatsui has discussed the presence of cloth as a leitmotif in his own work. Analogous to Renaissance humanists who carefully studied the visual language of Greek and Roman classicism and applied it to their own subject matter, Anatsui is a twenty-first-century artist intensely aware of Africa's art-historical traditions and infusing them with new life and meaning. Through the animated surfaces of his works, which are in a sculptural idiom, he calls attention to the comparable dynamism of Ghanaian textiles, whose shimmering luminosity, dense composition, and immense rippling presence viscerally engage the viewer.

Kente: Anatsui's continuing expansion of the formal and technical repertory of metal tapestry parallels the rich development of *kente* textiles produced by Ewe and Asante weavers. A comparison of *Between Earth and Heaven* and an outstanding nineteenth-century Ewe *kente* in the collection of the British Museum (cat. no. 1) reveals how profoundly Anatsui has considered such prototypes, both visually and conceptually.

Underlying both works is the dynamic tension between an established structural framework and the irregularity created by endless variation of design within each band. The *kente* composition consists of a measured sequence of seven distinct warp strips whose patterns are never exactly replicated. Each of the bands contains warp striping, weft-faced stripes, and supplementary-weft float patterning (for a discussion of these and other techniques, see Christine Giuntini's essay in this publication).

While the Ewe work maintains an overall density of its graphic design elements, Anatsui has concentrated this effect in the upper portion of his composition and allowed the solid gold to take over below. In *Between Earth and Heaven* the countervailing fibers of warp and weft are alluded to by short filaments of aluminum, cut from the neckbands of bottles, in an array of contrasting shades (frontispiece). The overarching structure evokes that of an Ewe man's cloth, made with, typically, twenty-four warp strips sewn together selvage to selvage and hung on the wall so that the strips span the width horizontally. In both *Between Earth and Heaven* and the British Museum *kente* cloth, the impact results essentially from the vigorous use of red inflected with black and gold. Although their respective materials seem dissonant, in fact the sheen of the silk *kente* fabric is echoed by the reflective gleam of Anatsui's metal surface.

This twenty-first-century tribute to *kente* is monumental in scope and scale; in contrast, the paintings and works on paper by Atta Kwami isolate discrete design details as one might highlight a musical passage from a score (figs. 2, 3). The images are not literal transcriptions of actual swatches of material but rather explorations of the internal relationships of color and pattern as filtered through the artist's visual imagination. Kwami's work also engages with both Ewe and

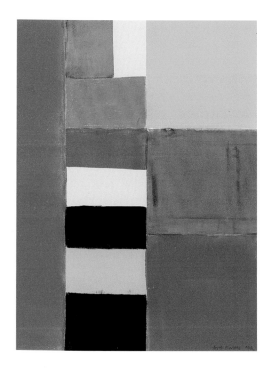
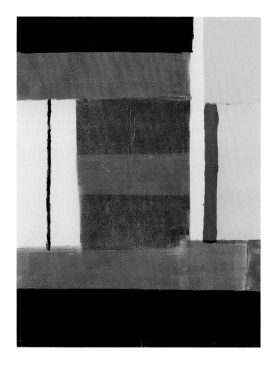

Figures 2, 3.
Atta Kwami (Ghanaian, b. 1956),
Vane (left) and *Kpong* (right), 2006.
Relief prints on paper, each
14 x 9¾ in. (35.6 x 24.9 cm).
The Metropolitan Museum of Art,
New York, Purchase, Janet Lee
Kadesky Fund, in honor of
Colta Ives, 2008 (2008.293.2,
2008.293.5)

Asante textile traditions on another level, by incorporating references to distinct stylistic approaches of different regions. His works on paper that form a series—*Kpong, Kpetoe, Vane, Tsito,* and *Juapong*—are identified by their musically sonorous names with towns in the Volta area of Ghana, where weaving is practiced in

regional styles that are recognizable to the discerning eye. Reflecting on the complexity of aesthetic associations underlying Kwami's work, Picton notes that if these images were isolated from the rich visual culture of Kumasi and Ghanaian textile traditions, "it would be easy to 'see' (and misinterpret) his work in terms of certain European modernist experiments: Paul Klee and Bauhaus textile design come to mind. And yet . . . at least some Bauhaus textile designs have their source in West Africa, specifically in Malian textiles."[3] As Picton goes on to observe, the Malian textiles that influenced the Bauhaus were also likely prototypes for the development of the distinctive Ghanaian *kente* textile traditions that have inspired Kwami. Both Kwami and European artists of an earlier era mined West African textile sources and responded to them, in ways that resonate with one another.

The earliest evidence of narrow-band woven textiles in West Africa is associated with the Tellem culture and was found in caves within the Bandiagara Escarpment in Mali at a bend of the Niger River. These remnants of cotton cloth in indigo and white have been radiocarbon dated to the eleventh century.[4] With them were some fragments of cotton woven with traces of wool and other fragments woven entirely of wool.

Essential to the development of the Tellem tradition was the establishment of trade between northern and sub-Saharan regions of the continent. With the introduction of camels to West Africa from southern Arabia by way of Sudan in the first centuries C.E., passage from north to south across the Sahara in two to three months became possible, and a network of trading centers developed. These arteries of exchange were the conduits through which, by the ninth century, Muslim traders disseminated their faith and transmitted other aspects of their culture. The patterning and widths of the fragments of wool textiles found at Bandiagara make it probable that they were among the enormous quantities of trade cloths from North Africa that crossed the Sahara. Those designs of which traces survive appear to be of Berber origin: they consist of a saw-toothed selvage motif favored in Algeria and Tunisia and a lozenge motif identified with Morocco.[5]

According to oral tradition, a Muslim saint, Enebi Ibrahima, introduced weaving into the inland delta area of the Niger River at the village of "Kesel."[6] Among the pastoral Fulani (also called Peul) peoples of this region are non-nomadic hereditary artisan castes, including the Maboube, whose male members are weavers and female ones potters.[7] Most notable among the many kinds of textiles produced by Fulani weavers are wool cloths of a heroic scale designed to be integrated into architectural interiors (cat. nos. 2, 3). On a practical level these wool blankets, or *khasa*, insulate their owners during the dry season, while their elaborate graphic compositions also create a distinctive aesthetic setting.

A closely related tradition was drawn upon by the Malian photographer Seydou Keïta for one of his most evocative portraits (fig. 4). He achieves a powerful formal tension by placing the bold checkerboard expanse of a Bamana cover blanket (*kosso walani*), spread over a bamboo bed (*tara*), against a backdrop of European damask embossed with a dense pattern of florid arabesques. Among the most common textiles woven by Bamana weavers, indigo-and-white *kosso walani* were in the past most closely identified with the Segou region.[8] The pensive woman

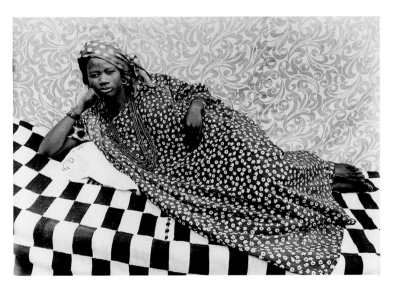

Figure 4.
Seydou Keïta (Malian, 1921?– 2001), *Untitled [Portrait of a Woman* or *"Olympia"]*, 1956–57, printed 1995. Gelatin silver print, 15⅜ x 21¾ in. (39.1 x 55.2 cm). The Metropolitan Museum of Art, New York, Anonymous Gift, 1997 (1997.267)

Figure 5.
Wrapper, Senegal, second half of the 19th century. Cotton, indigo dye, 59⅞ x 88¼ in. (152 x 224 cm). The British Museum, London (Af1934,0307.246)

who is the subject of the portrait, positioned on a diagonal and clad in a voluminous textile of a contrasting floral print, appears to levitate—suspended between two intersecting realms. This image eloquently overcomes the artificial distinction between "tradition" and "modernity" by bringing together a classical strip-woven cloth and an industrially printed one. The categories of "art" and "life" are also bridged, with the selection of the Bamana blanket transporting a Malian viewer beyond Keïta's studio setting and evoking instead a domestic interior.

Indigo Dyeing: The basic formal structure of West African textiles—composed as they are of long narrow bands of design assembled to suggest a field that has the possibility of endless expansion—also appears to be an aesthetic precept of profound resonance. As an organizational principle and conceptual template, it is replicated in textile design even where there is no practical reason for the scheme to be retained. Striking evidence is provided by the stitch-resist

indigo-dyed creations of Senegalese dyers. In both examples featured here (cat. no. 5, fig. 5), simple imported factory-manufactured cotton was used as the ground for artistic elaboration. Although the foundational cloth had none of the structural qualities of regional strip-woven textiles, these complex design schemes intentionally replicate those qualities: the sheet of cloth was torn into strips, which were invested with repeating stitched designs, dyed, and then reassembled. What may once have been merely a technical limitation of the weaver's capacities has been elevated to an abstract aesthetic and deliberately reconstituted in new idioms. Deploying an entirely different process and medium, the artist re-creates the widely appreciated visual experience of a field defined by bands of dense pattern, at once echoing designs produced on the loom and introducing new formal elements such as a densely applied, delicate stippling achieved with fine stitches.

We encounter a related sensibility in portraits taken by another acclaimed Malian photographer, Malick Sidibé (figs. 6, 7). In these, the bold vertical striations of a textile backdrop define the interior landscape of his studio and dominate the photographic compositions. Formal tension comes from the juxtaposition of the striped cloth with those worn by the subjects. The design of the wax print that unfolds in vertical columns for the length of the woman's skirt echoes and contrasts with the controlled structure of her environment. The fabric of the man's shirt is divided into rectangles that, when silhouetted against these same stripes, recall the units of floating design that West African weavers introduce into their woven strips.

In a dynamic counterpoint to these artfully calibrated compositions is the explosive visual impact of an astonishing work from neighboring Gambia (cat. no. 9). While this fabric consists of

twelve strips of hand-spun cotton woven on a man's double-heddle loom, the process used to tie-dye it with indigo has vehemently obliterated any signs of that underlying structure. The design's complete freedom and lack of containment suggest a deliberate defiance of structural constraints. In Senegambia and elsewhere in West Africa, the idea of the textile artist's individual freedom has been informed by the vocation's itinerancy—a reflection of the continual search for new patrons, the ambition to master new weaving techniques, and an ongoing quest for fresh inspiration.[9]

As Renée Boser-Sarivaxévanis noted, the various indigo-dyeing techniques employed in Gambia, Côte d'Ivoire, Sierra Leone, and Guinea are all found in Senegal.[10] She proposes that the works in the British Museum collected in the nineteenth century by Charles Beving Sr. (see below) constitute important material evidence that Senegal is likely to have been the center where these practices originated, before subsequently being disseminated by Soninke, Mande, and Dioula migrants.[11] Two other influential centers of indigo dyeing developed in Nigeria, among the Yoruba and Hausa. The aesthetic impact of indigo varies significantly in these different traditions, as is apparent in an array of distinct genres represented in this exhibition (cat. nos. 5–9, fig. 5). Yoruba artists working in *adire* (resist-dye) often paint freehand on cloth using a feather dipped in starch, dividing the field into a series of squares filled with different geometric and representational motifs in anticipation of the dyeing process. Hausa dyers in the city of Kano simply saturate plain pieces of cloth with dye and further burnish them through pounding until they attain a metallic sheen.

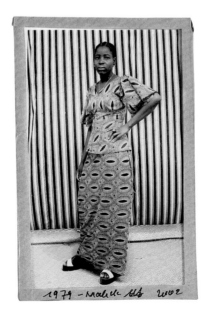
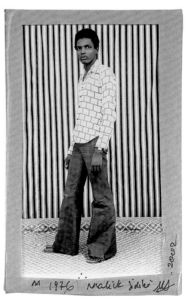

Figure 6.
Malick Sidibé (Malian, b. 1936), *Untitled [Woman Standing before a Striped Background]*, 1979. Gelatin silver print, 5½ x 3½ in. (14 x 8.9 cm). The Metropolitan Museum of Art, New York, Purchase, Nancy Lane Gift, 2003 (2003.160)

Figure 7.
Malick Sidibé (Malian, b. 1936), *Untitled [Man Standing before a Striped Background]*, 1976. Gelatin silver print, 5½ x 3½ in. (14 x 8.9 cm). The Metropolitan Museum of Art, New York, Purchase, Nancy Lane Gift, 2003 (2003.159)

The ubiquitous indigo is a deep blue dye obtained from various plants that has been used in virtually every culture. A purified compound of great value, indigo has been traded over great distances since antiquity. Tyrian purple, a dye with a very similar structure that was also highly sought after in antiquity, is obtained from the secretion of a sea snail. By the mid-ninth century B.C.E., tyrian purple was being exported across the Mediterranean from the Phoenician outpost of Carthage in North Africa.[12] It is likely to have figured prominently in exchanges between the northern and sub-Saharan regions of the continent as early as 500 B.C.E., when Berbers were using horses and donkeys to draw chariots south from Morocco to the Senegal River and from Carthage to the middle Niger River. In 1526 the North African traveler Leon l'Africain noted that "the blue cotton fabrics of the [sub-Saharan] Sahel were exported towards the Sahara."[13]

In 7 Variations on Indigo, an installation created in 2002 for the Centre de la Vieille Charité, Marseille, Rachid Koraïchi calls attention to the deep-seated appeal of indigo blue dye, the object of trade networks that historically have connected Africa, the Middle East, and Europe (fig. 8). One component of the work is a series of twenty-eight vertical banners made of silk that were woven and dyed with indigo in Aleppo, Syria. Each banner is filled with poetry drawn from Songs of the Recluse by the eighth-century Sufi female mystic Rabia al-Adawiya. By incorporating Sufi mystical writings into his work, Koraïchi seeks a quality of transcendence. The columnar inscriptions applied to the silk intertwine the artist's personal script and visual imagery with passages of reversed Arabic text. The work of this artist—born in Algeria, living in Paris, and traveling continually to Algeria, Tunisia, and Egypt—reflects a constant movement between innovation and the renewal of regional cultural traditions. Koraïchi strikes

this balance by collaborating with classically trained weavers and dyers who produce elements of his large-scale, multimedia, often site-specific installations under his supervision. Seven of the elegantly ethereal gossamer panels from 7 Variations are on view in the present exhibition. Designed to be suspended from above, they span the divide between heaven and earth while on a formal level monumentalizing the vertical strip omnipresent in sub-Saharan textiles.

Cloth and Identity: The customization of dress may reflect not only the taste and social standing of the wearers but also a desire to enhance their well-being. That is emphatically the imperative of a garment in the British Museum's collection made by an itinerant Hausa artist for either an emir of the Fulani of northern Nigeria or an Asante patron (cat. no. 11). Every inch of its surface is covered with calligraphic inscriptions derived from Koranic texts.[14] Small leather charm cases sewn to the inside, hidden from view, probably also contain extracts from the Koran. In Islamic belief the written word of the Koran has protective power, and undergarments carrying such texts were designed to shield the wearer from harm.

The lavishly embroidered, voluminous man's robes that are the fashion throughout much of Nigeria originated as attributes of rank for northern Nigerian elites. Once acquired only by inheritance or upon appointment to an honored position, such highly exclusive apparel announced the wearer's wealth, status, and identification with Islamic authority.[15] An early example (cat. no. 13), now in the British Museum, was presented to a British vice admiral by the king of Dahomey about 1863. With their sweeping breadth, such garments conspicuously consume vast quantities of fabric. Their design brought

Figure 8.
Rachid Koraïchi (Algerian, b. 1947), four panels from *7 Variations on Indigo*, 2002. Serigraphy on Aleppo silk, ink, and paint, each 12 ft. 6 in. x 18⅞ in. (320 x 48 cm). Collection of the artist

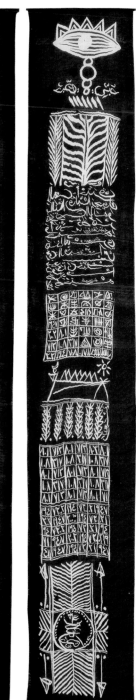
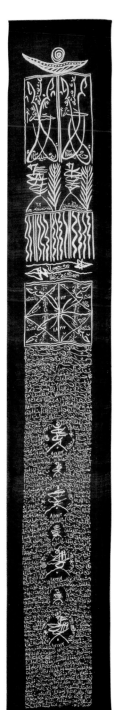
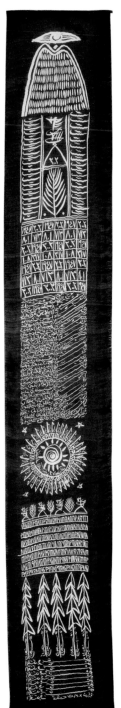

together the talents of professional Nupe weavers, embroiderers, and indigo dyers. The cloth was of woven cotton, produced in strips that are sewn together selvage to selvage; the patterns were typically fine stripes in shades of indigo and white, occasionally with other colors. In the nineteenth century a new fiber texture and new color were introduced with the addition of magenta silk threads extracted from goods imported from Europe through the trans-Saharan trade.[16] A formal accent—a visual tour de force—is contributed by the passages of ornate embroidery emblazoned across the chest and back, to which apotropaic power was attributed. Preliminary designs for these stitched inscriptions were drafted by Koranic scholars, who synthesized Eastern motifs with those derived from indigenous decorative arts.[17]

Cloth is tied to self-definition in many different ways. In some contexts the connection is especially overt, as when an accumulation of textiles over many generations represents the ultimate measure of a family's worth. The cloth chests of eastern Ijo families contain endless varieties of fabrics of African, European, and Indian origin acquired through trade.[18] Such collections place a premium not only on quantity but also on the range of traditions and genres gathered. The body of a female family member has often been the ideal venue for displaying such impressive wealth. A nineteenth-century observer described the visual spectacle of the wives of Bonny chiefs wrapped in abundant layers of textiles: "They sported sometimes five, six, or more pieces of different kinds of cloth about them, especially when going to any of their festivals, so that the body looks like a roll or truss of yarn at both ends."[19] Lisa Aronson has written of contemporary celebrations in Ijo, Kalabari, Okrika, and Bonny communities that mark the completion of women's rites of passage with a series of cloth-tying ceremonies.[20] In the first of the successive stages, the heaviest and oldest types of cloths are wrapped around the initiate. These especially noteworthy heirlooms may be Ewe strip-woven textiles produced in Ghana, several hundred miles away.

Sokari Douglas Camp's sculpture *Nigerian Woman Shopping* (fig. 9) is faceless, her presence defined by the spangled print of the "cloth" wrapped around her. She would be invisible were it not for its bold stars and crescents. Douglas Camp notes that the design deliberately evokes a popular Dutch wax print whose star-and-crescent-moon pattern, produced in bold yellow and blue, was recognized to be derived from Arab sources.[21] The Dutch textile company Vlisco has produced a series of prints for its West African clientele that are variations

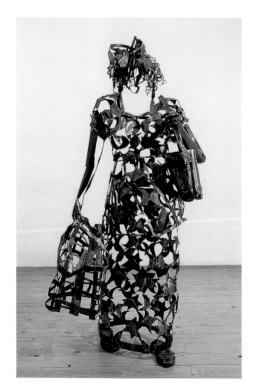

Figure 9.
Sokari Douglas Camp (British, b. 1958), *Nigerian Woman Shopping*, 1990. Steel, 70⅞ x 26 x 32⅝ in. (180 x 66 x 83 cm). Packman Lucas Collection

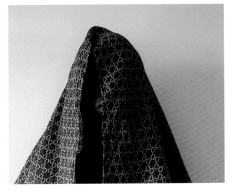

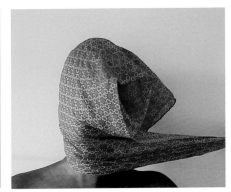

Figure 10.
Grace Ndiritu (British, b. 1976),
The Nightingale, 2003. Scenes
from a video (7 min. 1 sec.).
Collection of the artist

on this motif.[22] The woman who is the subject of this sculpture is anchored by a large bag of the kind colloquially referred to as a "Ghana must go" bag for its identification with the expulsion of displaced Ghanaian residents from Nigeria in the 1970s. Manufactured of woven plastic, such bags are often used for transporting cloth.

In *The Nightingale*, Grace Ndiritu films herself wrapping and rewrapping a simple piece of cloth around her head, disclosing a panoply of potential identities (fig. 10). The sequence opens with undulating, shifting, and rippling movements of the fabric, which appears to be an independently animate presence until the individual responsible for its movement is revealed. The cloth has a simple repeating pattern, and as its manipulation continues, we become aware that the gestures too are repeated. This modest piece of fabric is invested with a great deal of personal meaning. Ndiritu acquired it during her travels in India and relies upon it to shield her in unfamiliar environments. Accompanying the video are musical pieces by the popular Senegalese singer Baaba Maal, *Mi Yeenii* (Missing You) and *Allah Adda Jam* (God Give Us Peace), which transport us to West Africa. Ndiritu, raised in the United Kingdom by Kenyan parents, has pursued a firsthand experience of the African cultural landscape, including that of Mali and Senegal, in order to better understand her own identity. Artistically she feels an affinity with Henri Matisse and shares his interest in exploring the aesthetic qualities of textiles.

The European Textile Trade

Contributions to the long tradition of textile manufacture in West Africa include not only North African influences but also the direct involvement of European merchants in the cloth trade. Beginning with the Portuguese coastal explorations in the late fifteenth century, the focus of regional trade began to shift from north–south Saharan routes to the coast. The Portuguese remained the dominant maritime intermediaries through the sixteenth century; control passed to the Dutch in 1642 and the British in 1871. From the beginning, textiles were a major trade item, exchanged for gold, kola nuts, and slaves.[23] By the seventeenth century, fierce competition had developed among the forty-odd trading posts along the Gold Coast representing Britain, Holland, and Denmark. While European traders encountered a ready market for many varieties of cloth, it was apparent from the outset that their African clientele had well-defined and discerning tastes.[24]

Christopher Steiner has discussed the lengths to which European merchants and metropolitan companies went, as early as the seventeenth century, to determine African aesthetic preferences and anticipate continually shifting fashion trends.[25] It was clear that there was no monolithic "African" taste and that regional consumers were appreciative of innovation: "These [cloths] which were sometimes popular . . . were at other times out of fashion, or suited only [to] one part of the coast."[26] During the seventeenth and eighteenth centuries the commodity most highly sought by West Africans was woven and printed cotton from India, in great demand for its bright, nonfading colors and its affordability. Recognizing these preferences, European manufacturers began carefully calibrating and customizing their output. In the eighteenth century, Manchester factories produced an enormous quantity of imitation madras for their African clientele and succeeded in displacing most of the Indian prototypes.

One of the first documented collections of African textiles was compiled for market research before 1900 by Charles Beving Sr., an entrepreneur in the textile manufacturing industry, and given to the British Museum by his son in 1934. Born in Baden, Germany, in 1858, Beving worked in the cotton business from a base in Manchester, trading in Africa for all but a month or two a year. He eventually became a partner in a cotton printing company, Blakeley and Beving, and later founded his own company, Beving and Co. Beving's extensive collection of textiles from West Africa and Indonesia was made up of samples gathered for his firm to serve as models for its production of cloths developed for the African market. The "classical" African textiles featured in the present catalogue are predominantly drawn from this early source (see cat. nos. 1, 4, 5, 10, 14). All of them relate to textile genres that continued to be vibrant and were not supplanted by industrially manufactured cloth; rather, the manufactured textiles were integrated into the pool of goods that served an ever-expanding societal appetite for different varieties of cloth.

In the mid-eighteenth century the Dutch recruited troops from the Gold Coast to fight their colonial wars in Java. The troops returned to Africa with a taste for Javanese wax-resist textiles, which subsequently were introduced into the region. Toward the end of the nineteenth century, a Belgian printer in Haarlem, J. B. Previnaire, developed a process for manufacturing Javanese-type batik by using a French banknote-printing machine to apply resin to both sides of cotton cloth.[27] The resin cracked and was penetrated by fine lines of color,

producing a distinctive effect. While Indonesian consumers rejected these manufactured imitations, they were in great demand along the Gold Coast. Shortly afterward, factories in Manchester began using similar techniques to produce textiles for export to Africa. By the 1920s, firms in Switzerland, France, and Japan had adopted the process, and fierce competition ensued to develop designs that would appeal to local tastes and reflect topical concerns. Ruth Nielsen has noted that the plethora of new designs drew ideas from an array of other textile prototypes—Indian cottons, Javanese batiks, European prints, indigenous African textile genres—as well as traditional African symbols and motifs, historical events, current events, political figures,

natural forms, and geometrical motifs.[28] The contemporary wax-printed textiles that dominate the marketplaces of West Africa today continue that tradition. Many of them are now produced in Africa in manufacturing centers in Ghana, Nigeria, and Senegal, such as Akosombo Limited Textiles (ATL) in Accra, whose designers are locally trained in fine and applied arts departments of schools such as the Kwame Nkrumah University of Science and Technology (KNUST) in Kumasi, Ghana, where both Anatsui and Kwami studied.

Yinka Shonibare's use of Dutch wax prints in his work reflects on the history of trade between Africa and the West and the nature of that relationship, as well as on assumptions about creativity

Figure 11.
Yinka Shonibare (British, b. 1962), *100 Years*, 2000. Emulsion and acrylic on Dutch wax-printed cotton textile, painted wall, 98 in. x 27 ft. 11 in. (248.9 x 850.9 cm), each panel 11⅞ x 11⅞ in. (30 x 30 cm). Collection of Ninah and Michael Lynne, New York

and identity. His wall installation *100 Years* (fig. 11) takes the form of a sampler containing one hundred panels of wax prints that he purchased in Brixton, South London, and that Vlisco had manufactured in Helmond, Netherlands, for "African" consumers. The panels are arranged in twenty vertical columns, with each swatch of cloth stretched like a canvas, suggesting the highly circumscribed Western pictorial tradition. More than half of these are altered by painterly interventions that obliterate their designs.[29] Not only is it intentionally made difficult to distinguish between painted and unpainted panels, but the authorship of the textiles themselves is called into question, since, as noted above, their designs are often derived from other textile sources. Many of the prints highlighted (among them are "Bunch of Bananas," "Target," "Staff of Kingship," and "Alphabet") have been reproduced and reissued for a century.[30] The visual density of this tableau of contrasting patterns with an underlying conceptual order challenges the idea of the grid in modernism and invites association with the expansive monumentality, dynamism, and coherent structure of woven West African textiles; the intense orange of the backdrop accentuates the mounted panels' exoticism.[31] Yet *100 Years* also undermines distinctions between high and low art, heightening our awareness that artistic processes are cosmopolitan and African aesthetics inextricably intertwined with those of the world at large.

Africa's Most Resilient Aesthetic Tradition

As Elizabeth Péri-Willis has noted, the painter and writer Kofi Antuban was the first to identify the potential of using emblems of the West African Akan culture in modern Ghanaian art.[32] After Ghana gained independence in 1957, Antuban occupied a highly visible platform in Ghanaian society as cultural advisor to its first head of state, Kwame Nkrumah, and in this role he advocated drawing upon a meaningful vocabulary of vernacular cultural imagery as part of the forging of a new national identity. Among the manifestations of this practice was the prominent incorporation of motifs from Akan *adinkra* textiles—a venerable genre of textile hand-printed with symbols (see cat. no. 7)—into designs for new state emblems. A recognition of cloth as a pivotal form of individual and cultural identity also lies behind the long-standing practice in which political leaders commission the manufacture of commemorative cloth carrying their own images. On one level, Antuban's appropriation of iconographic motifs derived from textiles reflects the centrality of this medium of expression in the cultural experience of the peoples of the former Gold Coast. On another, it is a less nuanced, less sophisticated iteration of the same processes by which contemporary artists featured in the present exhibition have borrowed elements from regional idioms and synthesized them in their own systems of representation.

The designs, techniques, and materials of African textiles provide evidence of Africa's lengthy engagement with the world at large, in some instances vividly illustrating notable historical chapters of a past that we are aware of through other sources. We can only imagine how many visual clues to other episodes are present in these cloths but elude us because the histories are lost. Works that require significant technical skill and creative ingenuity, textiles have for centuries been a highly valued commodity, produced locally as well as imported from afar. While in some cases genres developed that have remained distinct cultural markers, others were broadly adopted by diverse populations across vast regions.

African patrons have consistently favored a cosmopolitan spectrum of textiles whose

aesthetics derive from a wide range of sources. For societies in which the maintenance of pre-colonial traditions presents enormous challenges, textiles are emblematic of cultural resilience. Generations after the celebrated sculptural traditions of the Fang and Baule peoples declined into obsolescence, *kente* cloth is still prolifically produced and avidly consumed in regional markets. Textiles continue to play a major role in the self-definition of individuals in contemporary Africa while simultaneously undergoing enormous creative innovation. The richness of Africa's textile legacy stems from two facts: the repertory of styles is continually expanding, and a great number of different affinities, tastes, and practices have long and gracefully coexisted. Clearly, in the realm of West African design and fashion there is no one formula that satisfies.

The exceptional textiles considered in this exhibition and catalogue exemplify a profound awareness of precedent. In Africa, textiles are ubiquitous artworks whose aesthetic draws upon both reservoirs of past practice and a thirst for innovation. At their core is the idea of design as an endlessly expansive continuum of formal possibilities, an approach that continues to resonate with creative practice. The visual language of textiles occupies a central place in the collective sensibility of many contemporary artists, whose sculpture, painting, video, and installations, as well as textiles, reflect on their experiences of the region. The highly personalized departures of their individual imaginations are ever sensitive to the synergy between classical traditions and the art of the present.

1. McNaughton 1982, p. 56.
2. Sieber 1972; Picton and Mack 1979.
3. Picton in *Kumasi Junction* 2002, p. 11.
4. Bolland 1991.
5. Lamb 1975, p. 80.
6. Imperato in Picton and Mack 1979, p. 107.
7. Gardi 1985, p. 359.
8. Pascal James Imperato, personal communication to the author, April 14, 2008.
9. Pitts 1978, p. 13.
10. Boser-Sarivaxévanis 1969, p. 153.
11. Ibid., p. 154.
12. Warmington 1969, p. 18.
13. Mauny in Baldwin 1979, p. 10.
14. Picton and Mack 1989, p. 163.
15. Perani 1979, p. 53.
16. Picton and Mack 1989, p. 108.
17. Ibid., p. 189.
18. Aronson 1982, p. 45.
19. Crow 1830, p. 219, quoted in Aronson 1982, p. 46.
20. Aronson 1982.
21. Sokari Douglas Camp, personal communication to the author, April 2008.
22. They are prints nos. 14/4173, 14/4243, and 14/3816.
23. Steiner 1985, p. 92.
24. Clarke 1997, p. 112.
25. Steiner 1985, p. 98.
26. Ibid., citing Wadsworth and Mann 1931, p. 150.
27. Clarke 1997, p. 114.
28. Nielsen 1979, pp. 482–84, cited in Steiner 1985, p. 93.
29. Hynes and Picton 2001, p. 94, n. 17.
30. Ibid.
31. Hynes and Picton 2001, p. 62.
32. Péri-Willis 1998, pp. 79–80.

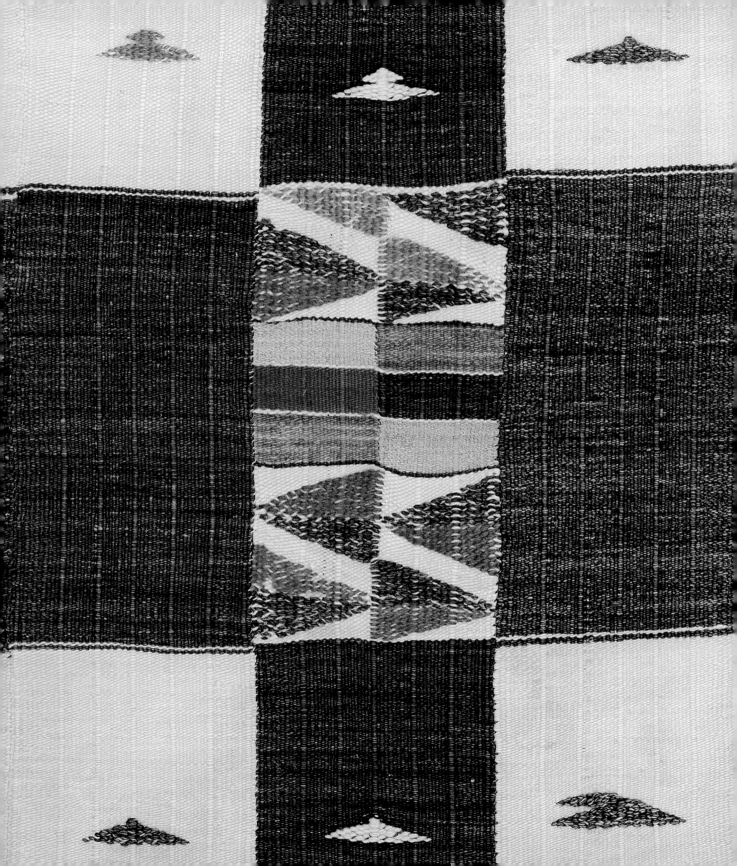

West African Cloth: Techniques and Tradition | Christine Giuntini

An ignorance of textiles is an ignorance of dominant cultural realities.[1]

Cloth, the Enduring Medium

Traditional African cloths, while visually stunning in themselves, can be most fully appreciated if viewed with an understanding of the materials and technologies used in their creation. Each West African textile or garment in this catalogue is testament to a particular collection of weaving and patterning traditions;[2] all were produced with relatively straightforward tools and by means of long-enduring technologies. The purpose of this essay is to examine a few of these traditions and reveal how creativity and skill were harnessed to produce cloth that both reflects and transcends the limits of the technology.

The largest group of textiles discussed here includes cloths that were handwoven in Africa, from either hand-spun or machine-spun yarns,[3] on one or another of several different types of West African looms (cat. nos. 1–4, 6, 9, 10, 12–15). Some of these handwoven cloths were patterned on the loom, while others were surface-patterned after weaving. Cloths created from a base of either imported or domestic commercial cotton fabric and subsequently decorated by means of one of the many West African techniques of surface patterning make up the second group (cat nos. 5, 7, 8, 11). Most, if not all, of the works in those two groups emerge from textile traditions that have existed for at least a

millennium[4] and continue to be practiced in West Africa today.

Factory-printed cloth constitutes a third category of textile that has broad popularity all over Africa. Specific types of factory-manufactured cotton cloths were developed by European entrepreneurs for the purpose of trade;[5] such cotton cloths are now manufactured in several West African states as well as imported. One type, known as wax-printed cloth, is printed on both sides with a resin-based resist prior to dyeing and stands out because of design characteristics developed exclusively for African clienteles.[6] Wax prints are more expensive to make than other types of commercially printed cloths because of the several stages of production needed to create the finished product. The images on wax prints (as on many kinds of hand-crafted West African cloths) tend to be equally clear on both sides of the fabric; this is in contrast with images on most other types of factory-printed cloths. Wax-printed cloths display distinctive color combinations and long-lived imagery as well as surface manipulations that include craquelure patterning and overlapping of color registrations.[7] In the past several decades an appreciation of this genre of cloth has also spread to Western urban centers such as London and New York.

In the large-scale installation piece *100 Years* (fig. 11), the contemporary artist Yinka Shonibare

| 25

draws inspiration from wax prints precisely because the patterns found on them have come to be associated with an African taste and sensibility. For Shonibare, cloth—of all the media—is the primary and enduring embodiment of the long interaction between African and Western cultures. In his work, truly, "the medium is the message."

Looms: Single-Heddle and Double-Heddle

Handwoven West African cloth usually has a plain-weave structure,[8] which is produced when one set of yarns interlaces over and under another set of yarns in an odd-even, or alternating, progression. The two sets of yarns are generally interlaced at 90 degrees to each other. Plain-weave interlacing can be accomplished by a number of techniques that demand varying amounts of time. In order to set up a loom, the yarns of one set, called the warp, are positioned parallel to each

other, secured into place, and then pulled taut so they are under tension. Tools may be added to the loom so that the warps can be organized into groups of odd and even yarns and separated from each other, allowing them to be more easily interlaced by the perpendicular set of yarns, called the weft. The opening that is created when the odd and even warp yarns are pulled apart is called a shed, and the ensemble of tools that carries out this work is the shedding device. Shedding devices range from simple collections of sticks (called shed sticks or rods), or sticks and strings (called heddles), to very elaborate systems that can produce complicated woven structures. Once a shedding device is in place, the odd and even groups of warps can be quickly and efficiently opened in alternation and the weft yarn can be passed through (fig. 13).

Much has been written about the various weaving traditions of West Africa.[9] John Picton

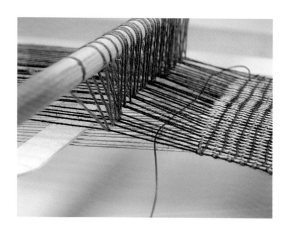

a

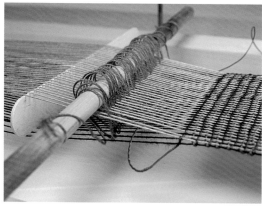

b

Figure 13.
A schematic loom.
(a) The heddle is raised, lifting the odd-number (here, dark-colored) warp yarns. The weft yarn is passed below them.
(b) The heddle is relaxed and the shed stick is used to lift the even-number (here, light-colored) warp yarns. The weft yarn is passed back below them.

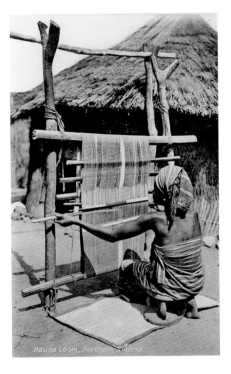

Figure 14.
Hausa Loom, Northern Nigeria, early 20th century. Postcard, 5½ x 3½ in. (14 x 8.9 cm). The Metropolitan Museum of Art, New York (PSC 2008.28). A Nigerian woman at work on a single-heddle loom inserts a weaver's sword into the shed—the opening between the odd and even warp yarns—before passing the weft yarn horizontally through the shed.

Hausa Loom, Northern Nigeria

and John Mack, in their seminal publication *African Textiles,* drew upon their own field work as well that of others to devise an African loom classification based on the shedding device. With appealing logic, they found that when specific variations are stripped away, African looms fall into two types. In one, the shedding device consists of a single-heddle and a shed stick; in the second, the shedding device consists of a set of two or occasionally more conjoined heddles (referred to as a double-heddle).[10] The usefulness of this basic distinction is evident in its continued use by scholars. Specific features of an individual loom and cultural information can then be considered when attempting further classification. Picton and Mack identify five types of single-heddle looms and five types of double-heddle looms that are used by West Africans and their close neighbors.

In West Africa, the single-heddle loom has traditionally been associated with woman weavers. It is generally used for weaving garments of cotton, a preferred fiber in tropical climates. Since cloths included in the exhibition that were woven on a single-heddle loom all come from Nigeria, one Nigerian loom type will be described here. It is constructed of two horizontal beams that are secured to posts at either side, creating a frame that keeps the vertical warp yarns under tension (fig. 14). The loom is set up perpendicular to the ground, often supported against a wall, and is generally referred to as a vertical single-heddle loom. One continuous length of yarn is used to create the warps. Usually one end of the yarn is secured to the left side of the lower beam and the weaver then passes it up and down around the two beams so that there are warp yarns on both sides of the loom. During this process two or more shed sticks may be added to the front yarns. As the yarn is wound onto the loom it passes either in front of or in back of these shed sticks to ensure that the warps do not cross over each other or become tangled together. (Usually, one or two of these sticks will be used to lift the first set of warps—either the odd or the even yarns—forming the first shed of the plain weave. The remaining stick will be employed as a guide for the tying of the heddle string that is used to lift the second set of warps, creating a second shed called the countershed.) Once the warping is completed, the heddle shedding mechanism and other sticks used to keep the warp evenly tensioned, spaced, and in the proper order are also applied to the front set of yarns only.

To weave the fabric, the weaver raises the heddle stick and inserts a wooden tool called a weaver's sword to help separate the yarns. She then turns the sword to hold the shed open, passes the weft yarn through, turns the sword back, and uses it to "beat in" the weft evenly

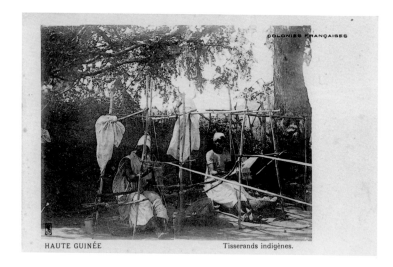

HAUTE GUINÉE — Tisserands indigènes.

across the width of the cloth, or web. Next the heddle stick is lowered and the shed stick is lifted and turned to hold the shed open. The weft yarn is passed back through and the sword again inserted, the shed stick is turned back, and the weft is beaten in. These two sets of motions are repeated over and over as the cloth is woven. [11]

The weaver begins work near the bottom beam, and as the weaving progresses upward, she loosens the lower beam temporarily so that the circular warp can be moved down and around the lower beam. She will continue to weave until the warp threads are almost entirely interlaced with weft yarns. The resulting fabric is tubular; the warps are then cut, yielding a length of fabric that is generally considered to be complete. Occasionally two or more widths are seamed selvage to selvage to make a wider cloth for a particular need. The width of cloth that can be woven on these looms varies; the loom's breadth is limited only by whether it is comfortable for the weaver to pass the weft back and forth through the warps.

The counterpart to this tradition is weaving on a double-heddle loom, once exclusively the purview of men (fig. 15). There are many variations in the construction and setup of the double-heddle loom;[12] a simplified discussion of its general method of functioning follows. Several features are common to all double-heddle looms. The web is always narrow, with the single strip of fabric produced being 13 inches wide at the most and as narrow as 1 inch wide. Most frequently the width is 3 to 5 inches.[13] This narrow woven strip has to be cut into equal lengths that are stitched together, selvage to selvage, in order to create cloths wide enough to be used for household purposes and as garments. This necessitates a warp of significant length. For example, if a finished cloth is composed of ten narrow strips joined together, each strip being 10 feet long, the uncut warp would have to be more than 100 feet in length (the weaver has to allow sufficient additional yarn for a fringed or hemmed edge and also for a certain amount of reduction in the total length as a result of the weaving process). The measuring, or laying out, of this long warp must be done with precision and with the assistance of several tools so that an exact

number of yarns of equal length are laid in the correct order, without any crossing or tangling, and this demanding work is often carried out for the weavers by specialists or apprentice weavers.[14] Once the appropriate number of warp yarns have been laid out, they are ready to be placed on the loom.

The double-heddle and a second tool, called the reed or beater, are suspended above the warp on a sturdy frame. These two tools serve complementary functions. The double-heddle opens the shed and countershed, while the reed keeps the warps evenly spaced across the web and also serves to beat in the weft yarn snugly after each pass. The two heddles of a double-heddle are joined together in such a way that when they are at rest they are in balance and the warps are more or less aligned in a single plane across the web.[15] When a force is applied to one heddle, it is pulled down and the other heddle is pulled up. This is accomplished by means of a cord and peddle attached to the lower end of each of the heddles and operated by the weaver using his feet. Since the sheds are changed by foot power, both of the weaver's hands are free to attend to the other actions involved in the weaving, thus accelerating the entire process.

However, warping the double-heddle loom is a lengthy procedure. While on the woman's loom the shedding device is added after the warping is complete, here each warp yarn must be secured to one or the other of the two heddles as it is being placed onto the loom.[16] Once the yarns are passed individually through the heddles and the reed, they must be secured at both ends so that the warp is kept under tension during the weaving process. Several methods of warp tensioning have been used in West Africa. All these technical distinctions continue to be important to both loom scholars and handweavers.

Woven Structure: Proportion and Effect

The proportion of warps to wefts in a plain-weave cloth can be varied to bring about a visual effect intended by the weaver. For centuries African weavers have exploited this capacity with great sophistication. When the warps are placed onto the loom so close together that they hide or almost hide the wefts, the fabric is said to be warp-predominant. When, on the other hand, a large number of wefts obscure a small number of warps, a weft-predominant fabric results. When the number of warps is approximately equal to that of wefts, a balanced weave results, and both elements play a role in the final appearance of the fabric (fig. 16). In every handwoven textile catalogued here, the proportion of warp to weft was adjusted in order to create a specific design outcome.

A Yoruba man's wrapper (cat. no. 10) is a warp-predominant weaving. The vertical stripes are created by groups of solidly dyed yarns placed so close to each other on the loom that they almost completely cover the weft yarns. This is true as well of the alternating bands of blue and white, which are produced not by a change in the woven structure but by a particular resist-dyeing technique commonly called ikat. The warp yarns of these stripes were patterned with the blue-and-white bands *before* they were woven. The dyer prepared the yarn for dyeing by first winding it into a long skein, then tightly binding some sections of the skein before it entered the dye bath. The protected areas remained white, while the uncovered areas were dyed a deep indigo. After the resist binding was removed, the yarns were laid out in their proper places along with the rest of the yarns and then warped onto the loom prior to weaving. With their slightly offbeat rhythm, the white passages pop out of the vertically striped ground, adding

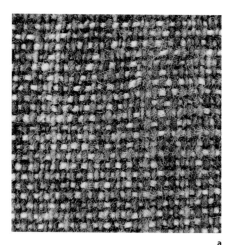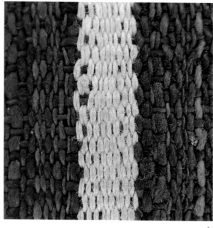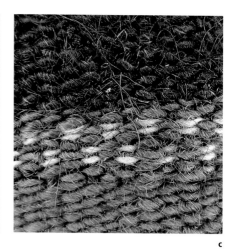

a · b · c

contrast and liveliness to what could have been a rather somberly toned cloth. The combination of warp stripes and a warp-ikat technique is a solution to the problem of how to create a pattern that appears with equal strength on both sides of a plain-weave cloth.

A *kpoikpoi* cloth (cat. no. 4) is an example of a weft-predominant weaving. In this cloth the warps are quite thin and widely spaced across the web, while the thicker weft yarns were tightly packed together by the weaver so that they completely cover the warps. The pattern possibilities in this type of plain-weave fabric are restricted to weft effects; changing the color of the weft is an obvious method of patterning, and it is also rather easy for the weaver to manipulate the weft to create patterns. Two different weft effects were used in the making of this cloth. One is straightforward plain-weave patterning with solid-color horizontal bands of varying widths. In addition, the weaver added bands filled with small diamonds, created by

supplementary-weft patterning.[17] Since the cloth is composed of ten strips each more than 11 feet in length, the same overall pattern had to be precisely repeated ten times along the uncut warp. Clearly the final design was preplanned, although likely only in the mind of the weaver. Perhaps he used sections of the woven cloth as a measuring aid to reproduce the pattern accurately. Although the diamond bands have a slightly different appearance front and back, there is a careful balance between the indigo of the plain-weave and the white of the supplementary-weft "floats." The resulting cloth has two beautifully finished faces.

A *kente* prestige cloth (cat. no. 1) created from seven differently warped loom lengths displays a wide variety of warp-stripe and weft-band effects. The Ewe practice of combining both warp-predominant and weft-predominant structures in a single cloth is made possible by a second double-heddle attached to the loom frame. In this design scheme, the slightly warp-face

stripes are broken by weft-face bands, some of which also contain supplementary-weft patterns that appear with equal clarity on both sides of the cloth. The first set of heddles, which is closer to the weaver, is used to weave the warp-predominate stripes. The horizontal bands and the supplementary-weft patterning are created using the second set of heddles. Whereas the first double-heddle is warped in simple odd-even alternation, thus forming the plain weave of the striped areas, for the second double-heddle the warp yarns are gathered into groups, traditionally six warps, and threaded in alternation. Since the weaver lifts the warp yarns in groups, the relative proportion of warps to wefts is reduced. The thin wefts can now easily cover the thicker warps, forming a weft-predominate weave. However, in those weft-face areas the more tightly grouped warps tend to be pulled together when the weft is beaten down, resulting in wavy selvages and uneven warp tensions that can cause extreme distortion in the finished cloth. An accomplished weaver, such as the maker of this cloth, is able to minimize that tendency.

Standing out among the warp-face stripes and weft-face bands is a checked pattern that was created using a balanced weave structure. The weaver warped his loom with six yarns of white cotton alternating with six yarns of blue cotton until the final width was achieved. When weaving these sections he interlaced four white wefts in alternation with four blue wefts across the web. The checked pattern occurs because the blue and white areas appear as solid colors when warp and weft of the same color interlace, while the mixed areas appear as a lighter blue-gray. This effect can be achieved only when both warp and weft are visible in the finished fabric.

While the examples just discussed were created on a double-heddle loom, any of their woven effects could have been produced on a single-heddle loom. Such a loom was used to make an Akwete woman's wrapper (cat. no. 14), whose slightly warp-predominant ground fabric serves as a continuous canvas upon which to weave supplementary-weft patterns without restrictions—making possible a high degree of innovation and creativity.

The fine salmon pink warps are doubled in order to balance the thicker red weft yarns more effectively, but they do not cover them completely, and thus both warp and weft are visible in the ground fabric. On close inspection the ground fabric appears to be composed of dots in two colors, which our eyes blend, and this "pointillist" mix of shades, whether intended or not, enlivens the fabric in a way that a single color could not do. The design set against the ground fabric is created from bundles of thin yarns and is woven in a discontinuous supplementary-weft pattern. Because they are always bound in at every sixth warp (between two passes of the foundation weft), these floats are vertically aligned. The untwisted yarns bulge out over the surface, bringing the pattern into slight relief.

A woman's wrapper (cat. no. 15) builds its visual interest from the interaction of solids and voids woven into the cloth. This elegant, airy fabric is composed of two panels, woven on a woman's vertical loom, that have each been joined along one selvage to a center band of factory-woven cloth. The two handwoven panels feature a contrast between a balanced plain weave and a warp-predominant weave and are subtly patterned with horizontal bands composed of hundreds of narrow columns that twist and turn out of plane. Each column is created from a group of six or ten warp yarns that were woven together as an individual unit. The weaver carefully controlled this effect by doubling the weft for the solid bands and using a single weft for the openwork bands. A single weft yarn allows

1. *Kente* prestige cloth

Ghana; Ewe peoples
19th century
Cotton, silk
Warp 74 in. (188 cm), weft 9 ft. 1⅞ in. (279 cm)
The British Museum, London (Af1934,0307.165)

Provenance: Collected in West Africa between 1880 and 1900 by Charles Beving Sr.; gift of his son to the British Museum, 1934

Richly elaborated and costly *kente* textiles, identified with wealth and status, are attributes of prestige worn to mark special occasions in both Ewe and Asante societies. In the Ewe communities of southwestern Ghana and western Togo, these include festivals, religious celebrations, and important transition events in an individual's life. The cloth, worn as a voluminous toga-like garment, is draped majestically around the body with one loose end brought up and over the left shoulder.

Although Asante and Ewe weaving traditions appear to have developed independently, they followed parallel courses.[1] Essential to the development of both were the introduction of the use of two double-heddles on a horizontal treadle loom and the refinement of cotton fiber for weaving. The Asante, living in south-central Ghana, imported raw or spun cotton from the north, whereas in some Ewe regions it was grown locally. Woven strips produced by Asante and Ewe weavers are generally between 3 and 4½ inches wide. For the creation of a complete *kente* cloth, the very long fabric woven on the loom is cut at fixed intervals to produce a series of strips that are sewn together selvage to selvage. An Asante man's cloth typically requires twenty-four strips. The earliest strip-woven cloths produced in these centers, Doran Ross suggests, were plain weaves made of simple undyed cotton and others with indigo warp stripes enhanced by simple weft motifs.[2] While the play of color and design

that unfolds across the oldest documented examples of *kente* appears random and idiosyncratic, in time regularly alternating pattern was explored.[3] Subsequently, Asante leaders acquired silk textiles through trade, and local artists unraveled them to obtain silk threads of many colors.[4] This influx of new imported fibers allowed the *kente* palette to be dramatically intensified.

This *kente* cloth, composed of twenty-four strips, each approximately 3 inches wide, woven of commercial cotton and silk, is a tour de force—an outstanding example of the most sumptuous type of cloth created by Ewe weavers. The strips come from seven loomed lengths, each with a different warp arrangement. The resulting vertical stripes present rhythms of repetition that are not immediately discernible. To further vary the pattern, the colorfully striped asymmetrical strips are set in opposite directions so they mirror each other. The long, slightly warp-face stripes are broken by horizontal weft-face designs, some of which are inlaid with more intricate supplementary-weft patterns. (For a discussion of this technique, see pp. 30–31.) Particular cloth patterns originated by Ewe weavers were passed down through the "pattern books"—bags of sample strip ends—that most weavers possessed.[5]

This example is not typical of Ewe weavings, which historically differed from Asante ones in their emphatic checkered effect, produced by the weaving of square sections that are alternately warp-faced and weft-faced, and in their frequent inclusion of representational motifs. In contrast to that of the Asante, Ewe weaving was not produced for a court or royalty. Instead, individual patrons were unrestricted in their ability to order cloth that reflected their own taste and financial means. Over time these neighboring traditions gradually converged. Ewe weavers not only

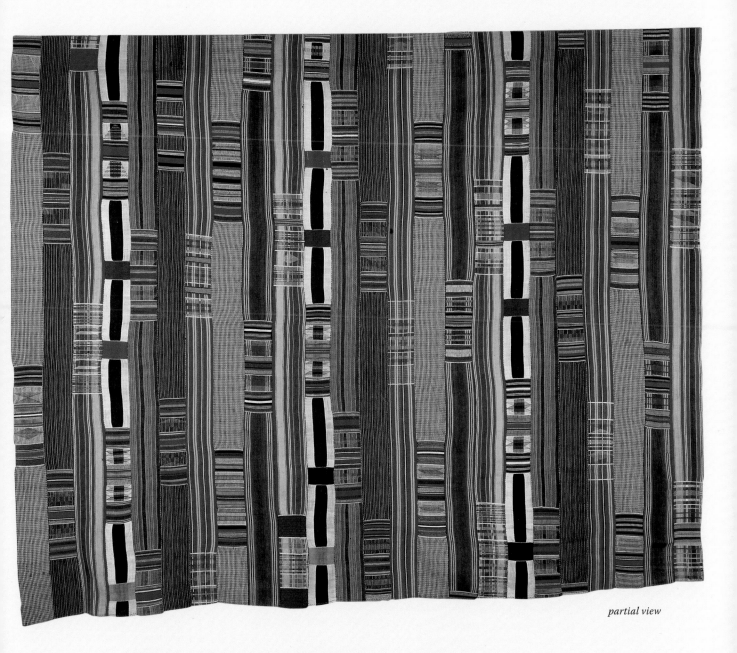

partial view

adopted Asante *kente* designs into their own repertory but also now work as some of the leading practitioners at the weaving center in the village of Bonwire, where textiles are produced for the Asante court at Kumasi.

1. Ross 1998, p. 78.
2. Ibid., p. 75.
3. Cole and Ross 1977, p. 39.
4. Ibid., p. 38; Ross 1998, p. 78.
5. Posnansky 1992, p. 123.

2. Interior hanging

Mali or Ghana; Fulani(?) peoples
19th century
Cotton, wool, natural dye
Warp 10 ft. (304.8 cm), weft 51 in. (129.5 cm)
The Metropolitan Museum of Art, New York, Rogers
Fund, 1971 (1971.30)

Provenance: Collected in West Africa and brought
to Salem, Massachusetts, by Joseph Upton during
the 1870s

Large-scale textiles created south of the Sahara were generally intended as enhancements for domestic environments.[1] The principal type of textile produced by Fulani weavers was a blanket woven of hand-spun sheep's wool, known as a *khasa*, that primarily functioned to enclose and define a space for personal use. The present rare work is far more elaborate and ambitious than most in that genre, and its place of origin has not been possible to determine in the absence of documentation. Woven principally of cotton and in narrow strips, it has features that suggest relationships to both cotton- and wool-weaving traditions. So complex and refined a textile must have been commissioned by a chiefly patron, perhaps to serve as a spectacular hanging.[2]

Composed of fifteen strips each about 3½ inches wide that extend its entire length, the blanket was designed to be hung horizontally. Executed by a master weaver, it has an intricate composition that is symmetrical and carefully balanced. Its subtle palette is made up of hand-spun yarns: white, three shades of indigo, and ecru cotton, along with pink wool. A bold median band spans the center, and broad striped borders accentuate both ends. Between these the field is subdivided into nine rectangular units, of which

the four outer ones are filled with a checkerboard design. The others, in light colors, suggest a negative space whose cruciform shape is echoed by the narrow, linear elements that cross it. Smaller patterns were created within the individual strips by juxtaposing rectangular and triangular color blocks, some accomplished by supplementary-weft patterning and some by tapestry weave, in which a colored weft yarn is worked back and forth in a limited area.

Once it was woven according to the pre-planned design, the length of fabric was cut into the strips that were assembled to produce this complex expanse of checkerboard blocks, bands, and crosses. The alternation of dense graphic elaboration with lighter passages allows the composition to breathe and gives it a sense of openness. The checkerboard, a basic West African composition, ultimately may derive from Islamic influences. Inscribed "magic squares" carry mystical significance in Islam, and the orderly cosmos is often symbolized by an arrangement of squares emanating from a central point.[3]

1. Imperato 1973, pp. 40–47, 84.
2. Picton and Mack 1989, p. 105.
3. Gilfoy 1987, p. 45.

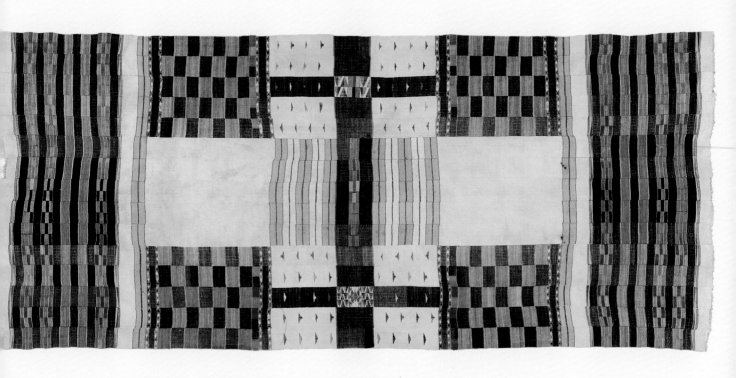

3. *Arkilla kereka* interior hanging

Niger, Tillabéri; Fulani peoples
First half of the 20th century
Wool, cotton, natural dye
Warp 13 ft. 6 in. (411.5 cm), weft 50 in. (127 cm)
The Metropolitan Museum of Art, New York, Gift of
Labelle Prussin, 1997 (1997.446.1)

Provenance: Purchased by Labelle Prussin from a
Hausa trader in Accra, Ghana, 1963

Cloths of this type, known as *arkilla kereka,* are tent dividers and marriage-bed hangings.[1] Belongings of grandeur and refinement, they were the most costly textiles produced in the Niger River–bend region and were almost always woven on commission. This work was woven at Tillabéri in western Niger.[2] Its aesthetic reflects the cosmopolitan engagement of weavers south of the Sahara with the formal vocabulary of North African textile traditions, and its patterns closely parallel those of Berber weavers. These designs may have once had protective associations.

While adopting the visual motifs of its models, however, this work significantly differs from them in construction, revealing that West African weavers went to great lengths to translate into their own idiom the sensibility of North African trade cloths. Berber women weave wool cloths for clothing on a wide vertical loom thought to be of pre-Arabic origin, and the geometric designs they produce occur in bands across the weft.[3] However, in the western Sudan, an area that includes Niger, men weave wool textiles on double-heddle looms, and the long, narrow fabric that is produced is cut into strips that are stitched together to form the completed cloth. In order to reproduce the effect of the North African cloths, the weaver had to calculate accurately the distance between motifs so

that they would match up once the strips were aligned. West African weavers thus relied upon a technically more challenging method than that of their models when re-creating Berber designs.

This fabric, primarily woven of wool, is now composed of four strips, each about 13 inches wide (originally it probably contained six strips, as comparable examples do). The stretchy wool warps are heavy to lift during weaving, and considerable tension must be placed on them in order to beat down the weft; therefore the cloth had to be sturdily constructed from strong yarns. The work's earthy palette of russet, dark brown, yellow, blue, and white is patterned with tapestry and supplementary-weft structures in weft-face bands. Each strip is subdivided into many horizontal registers, some solid, some featuring floating motifs. The areas of supplementary weaving result in a textile that has distinct patterns front and back. With its decorative designs exactly repeated and perfectly synchronized, the resulting cloth becomes a flawless continuum of dense pattern.

1. Imperato 1976, pp. 57–59, 92.
2. Picton and Mack 1979, p. 110.
3. Picton and Mack 1979, pp. 62–67.

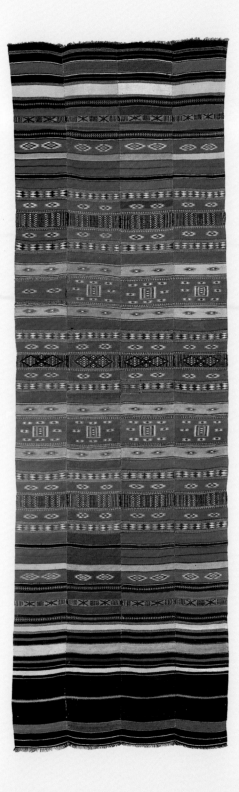

4. *Kpoikpoi* cloth

Sierra Leone; Vai or Mende peoples
Second half of the 19th century
Cotton, indigo dye
Warp 11 ft. 1⅞ in. (340 cm), weft 62¼ in. (158 cm)
The British Museum, London (Af1934,0307.178)

Provenance: Collected in West Africa between 1880 and 1900 by Charles Beving Sr.; gift of his son to the British Museum, 1934

The astonishing scale of textiles of this type, produced by Vai and Mende weavers in Sierra Leone, constitutes an epic pictorial statement. Cloths woven on the double-heddle man's loom in a range of related patterns and color schemes, incorporating stripes and supplementary wefts in distinctive geometric patterns, are produced across a wide area of Sierra Leone and Liberia. Cloths of the distinctive variety known as *kpoikpoi* are the creations of specialist weavers. Composed of broad weft-faced strips, these impressive textiles contain patterns made by tapestry weave and supplementary-weft floats in different combinations. Such grandiose textiles may attain a length of 30 feet. They were a luxury commodity traded by Manding merchants and were used as wall hangings unfurled to mark special events, wrappings for deceased notables, and payments for dowries and court fines.[1]

This cloth is composed of ten strips, each about 6¼ inches wide. Its design, consisting of many horizontal bands of varying widths and alternating colors, was duplicated ten times along a single warp length—a highly demanding operation. The various formal elements include broad white bands, thin dark indigo lines, broad indigo bands, broad light blue bands, and blocks of either indigo or white lozenges. To create these delicate lozenges, the weaver doubled the white weft yarn and used it as a supplementary element that floats over and under the plain-weave foundation. While subtle deviations occur in the execution of the bands, the overall effect is that of a single overarching design.

1. Picton and Mack 1979, pp. 105–6.

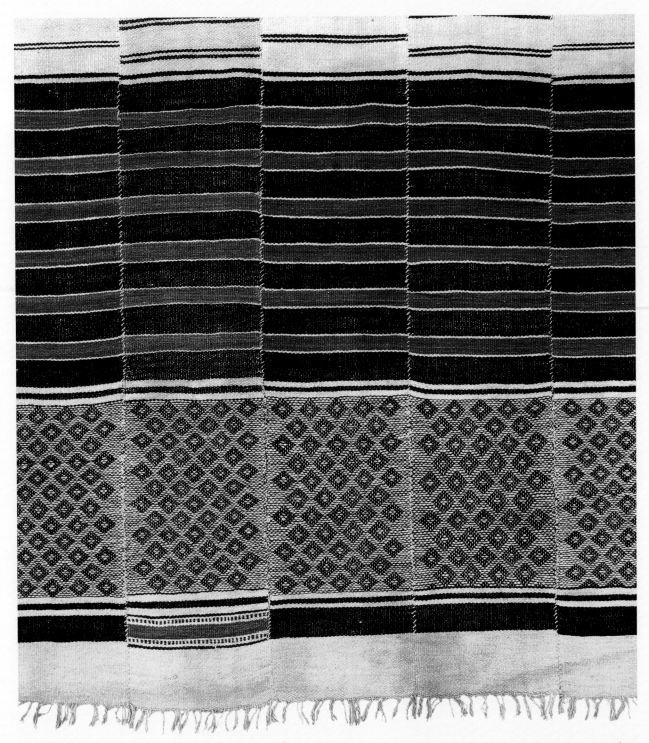

detail

5. Wrapper

Senegal
Second half of the 19th century
Cotton, indigo dye
Warp 95 ⅝ in. (243 cm), weft 57 ⅛ in. (145 cm)
The British Museum, London (Af1934,0307.241)

Provenance: Collected in West Africa between 1880 and 1900 by Charles Beving Sr.; gift of his son to the British Museum, 1934

At first glance this cloth composed of conjoined vertical units appears to be another example of strip weaving. The impression is, however, an illusion: the author instead reproduced the look of that familiar structure by an entirely different creative process. The point of departure was an imported, commercially manufactured, fine cotton plain weave. It was torn into fifteen strips, each approximately 3¾ inches wide, which were then readied for dyeing.

Each strip was stitched with intricate patterns, including particularly elaborate ones at the ends. The designs may be of Hispano-Moresque derivation, based on motifs transmitted by Arab sources into the Iberian Peninsula and then introduced along the coast of West Africa by the Portuguese.[1] This stitching can be conceived of as temporary embroidery. To achieve the desired depth of color, each strip was immersed several times in the indigo bath, with the especially intense blue borders likely requiring additional immersions. Once the dyeing process was completed, the embroidered stitches were unpicked. The tighter the stitches, the more resistant their area was to the dye. Reproducing the same effect with such precision on each of the bands was a feat of considerable skill on the part of the embroiderer. Only after the patterning had been achieved were the strips stitched together into a single piece of cloth. Unraveling the weft and finishing the exposed warp ends into a fringe completed the work.

The severe rectilinear format of this cloth is countered by a dense "pointillism." The composition is unified by the deep indigo bands accented with abstract cruciform motifs that enclose it on either end. In planning this composition the artist quoted and transposed the widespread paradigm of strip-constructed design. On the one hand, this ingenious formal solution may be seen as a less costly way to evoke the process of woven design. On the other hand, it reveals the enduring centrality of that visual template in the aesthetic consciousness of those who express themselves in this medium.

1. Antonio Carreira, quoted in Baldwin 1979, p. 24.

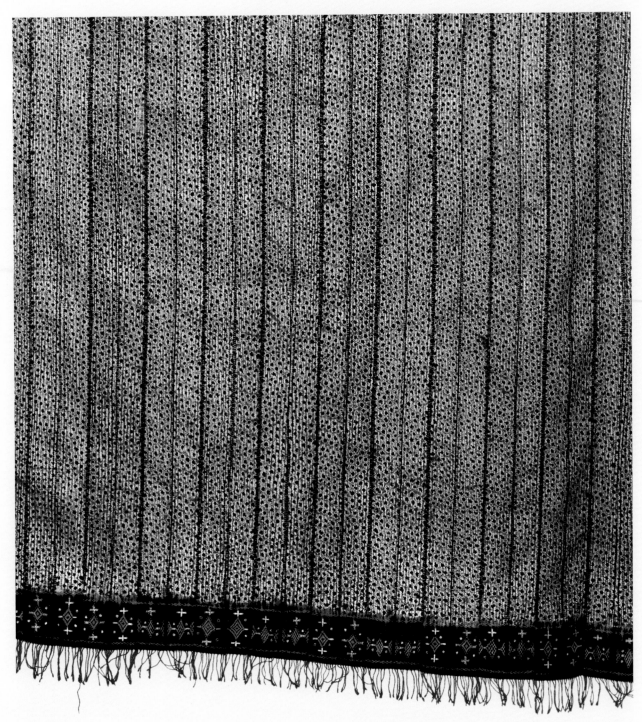

partial view

6. Display cloth

Nigeria, Wukari region; Jukun peoples, Abakwariga
group
19th century
Cotton, indigo dye
Warp 16 ft. ⅞ in. (490 cm), weft 84¼ in. (214 cm)
The British Museum, London (Af,WA.11)

Provenance: Acquired by the British Museum in the
19th century

The term *ndop* is often used to refer to hand-woven textiles with bold designs produced by indigo resist-dyeing. This tradition appears to have originated in the Wukari region of Nigeria, where it is practiced by individuals belonging to Abakwariga families that have settled in Jukun communities but are of Hausa origin.[1] Such textiles are used in Jukun culture as funeral shrouds, or *akya*, but they are also in great demand for export to royal patrons in neighboring Cameroon. There they provide an impressive backdrop for leaders on important occasions of state.

The resist process used to produce this work is similar to that of the previous example. In this instance the allover design was applied to a canvas previously assembled from thirty narrow strips, 2¾ to 3 inches in width, that were woven from very fine, evenly spun yarns. Raffia fiber was used to stitch the pattern into the cotton fabric before dyeing. The clarity of the pattern and the sharp contrast between the white and the indigo are the result of fine, close, even stitching and a carefully controlled indigo bath.

The design unfolds as a continuous field of interlocking disks, each with a four-petal motif at its center. The circular element can refer to the sun, a Jukun symbol of power. Subtle alternation is introduced by filling the negative spaces with either a dotted pattern or a grid filled with squares. In the interstices between disks is an abstract linear motif that suggests interlaced yarns. The resulting dense and highly structured pictorial field is framed by a series of concentric borders that repeat elements of the interior motifs. Although similar textiles have come to be produced in Cameroon, the elaborate framing device is a signature feature of works produced in Wukari.

Certain attributes of this work are particularly characteristic of Hausa dyeing practices. Among them is an extraordinarily glossy sheen. It is achieved by exploiting the fact that the fabric, heavily overloaded with dye, can be manipulated, especially by pounding, to bring out a shiny, burnished effect.[2] In such instances, the medium of cloth may evoke the stiffness and luminosity of metal.

1. Picton and Mack 1979, p. 150.
2. Ibid., p. 147.

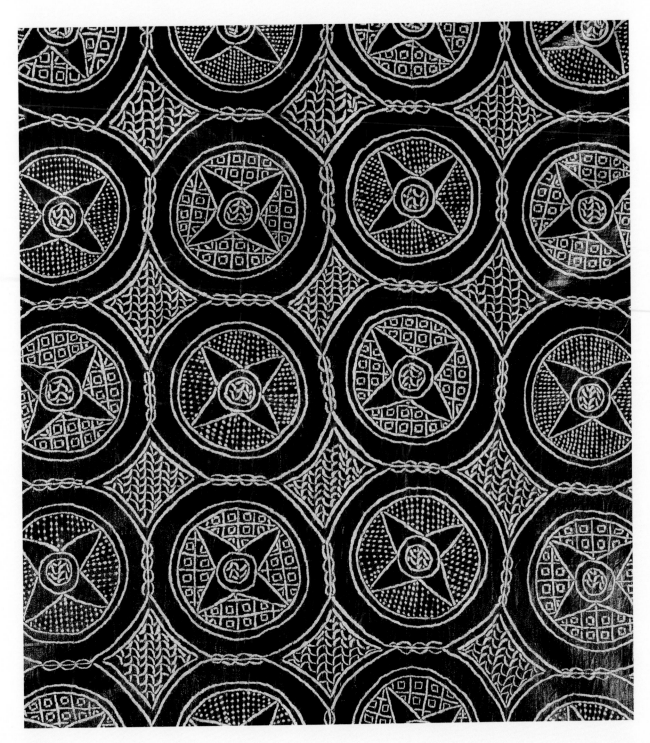

detail

7. *Adinkra* ceremonial wrapper

Ghana, Brong-Ahafo region, Mim village; Akan peoples,
Asante group
First quarter of the 20th century
Cotton, indigo dye, pigment
Warp 91 ⅜ in. (232 cm), weft 44 ⅛ in. (112 cm)
The British Museum, London (Af1935,1005.2)

Provenance: Purchased in the village of Mim, Brong-
Ahafo region, Ghana, by A. F. Kerr, 1934; his gift to the
British Museum, 1935

In Akan culture *adinkra* cloths underscore the relationship between the living and ancestors, the present and the future, concerns of the moment and those of the hereafter.[1] These rectilinear cloths are worn wrapped around the body like a toga to mark various notable occasions. Their compositions are conceived of as visual texts; *nkra* may be translated as "message" or "intelligence." The reference is to a divine transfer of knowledge when the soul passes on to the afterlife. The visual language of these textiles thus addresses concerns of transcendent importance that define their aesthetic.[2]

The creation of *adinkra* begins with the selection of a fabric of considerable scale that is either plain white or has been dyed brown, red, green, purple, or blue. Cloths dyed red or black are intended for wear at funerals and related to mourning, while white and other bright background colors are appropriate for festive celebrations and are referred to as *kwasiada* (or, Sunday) *adinkra*. At one time the fabric put to this use was locally woven cloth produced from hand-spun cotton. More recently, manufactured imported fabrics have been used—in this case, plain-weave cotton. Once the foundational surface has been selected, it is systematically mapped. A dark pigment, prepared from boiling together tree bark and iron slag, is applied to the cloth with a comblike instrument so that the field is subdivided into a rectilinear template. Although

the black colorant seeps into and dyes the fabric, much of it remains on the surface, forming a shiny relief. Within the grid each square is filled with rows of a single abstract or representational graphic motif, either painted or applied with a stamp carved from a calabash rind. The result is a series of frames within which distinct motifs are concentrated. The hand-drawn framing device may evoke the structure of strip weaving as well as Islamic diagrams of an orderly cosmos as an arrangement of squares emanating from a central point.[3]

The author of the *adinkra* selects which motifs will be represented and where they will appear within the overarching scheme. Captain R. S. Rattray, a colonial-era ethnographer of the Asante, recorded fifty-three different *adinkra* signs, each named and imbued with historical, allegorical, or mystical significance. In the present example at least thirteen of the signs appear. They include a concentric circle, *adinkrahene* (*adinkra* king), which is considered paramount among the designs; an undulating lattice, *aban* (fence), which invokes protection and security; and a diagonal linear lattice, *nhwimu* (crossing), which evokes the notion of precision through the divisions drawn on the plain cloth before the stamping of *adinkra*. The others featured are *dwannimmen* (double ram's horns), a symbol of leadership, strength, and humility; *ananse ntontan* (spider web), identified with cunning,

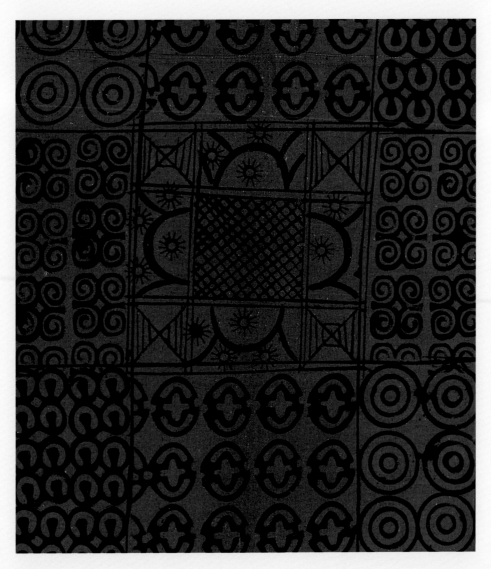

detail

intelligence, and creativity; *nkuruma kese* (big okra), emblem of greatness and supremacy; *kra pa* (good fortune and sanctity); *fihankra* (compound house), associated with safety, security, and solidarity; *krado* (seal of law and order), symbolizing the authority of the court; *mpuannum* (five tufts of hair), a traditional hairstyle; *bi-nnka-bi* (bite not one another); *gyawu atiko* (hairstyle of bravery), first worn by the general Gyawu during a war victory; and *abete ntema* (equitable distribution of resources).[4]

1. Cole and Ross 1977, p. 44.
2. Ibid.
3. Gilfoy 1987, p. 45.
4. Rattray 1927, pp. 265–68.

8. *Adire* woman's wrapper: Olokun

Signed by Olewabehn
Nigeria, Ibadan; Yoruba peoples
First half of the 20th century
Cotton, indigo dye
Warp 77⅛ in. (196 cm), weft 69¼ in. (176 cm)
The British Museum, London (Af1971,35.17)

Provenance: Collected in Oje market, Ibadan, Nigeria, by Mrs. Jane Barbour, 1971

Adire is the Yoruba term for resist-dyed cloth primarily created by women in the cities of Abeokuta, Ibadan, and Oshogbo in south-western Nigeria. This work is a classic example of *adire eleko*, a term that refers to the painting of graphic designs onto one side of the cloth with starch made from cassava flour before dyeing. The starch paste resists the indigo dye and when removed by scraping and washing at the end of the process leaves undyed areas against the dark ground. The paste resist was delicately painted on with a palm rib or bird's feather brush. The fine yarns and tightly woven structure of industri-ally manufactured cloth made it the preferred medium for this art, since the smooth surface allowed for the rendering of fine detail. To mute the degree of contrast across the patterned surface, the dyed cloth was immersed into the indigo bath a final time after the removal of the paste resist.

This wrapper is composed of two lengths of factory cloth joined together in the warp direc-tion to form a single rectangular panel. The com-position is subdivided into squares that are filled with geometric and representational images. Each half of the panel is made up of two rows of five squares, with narrow rectangles at each side and twelve small squares at the top and bottom.

The repertory of motifs drawn upon for this work is identified with a genre known as Olokun, which is the name of the deity of the sea and of wealth. The iconography is also known as "Life is sweet." It is associated with bounty and pros-perity, delivered through trade. While individual freehand executions vary in style, the imagery of the ten large squares follows an established pro-totype.[1] The vocabulary of exacting motifs juxta-posed in these dense compositions is passed down from mother to daughter. The designs range from geometric patterns to images of croc-odiles, fish, chieftaincy, leaves, birds, scorpions, plantains, matches, and spinning tops. As noted by Nancy Stanfield, individual painters render these motifs so differently that no two interpre-tations are the same.[2] Often, as here, the author places her own mark or signature on the hem. In the last decades of the nineteenth century a method for standardizing this highly labor-intensive process was introduced by male dyers, who cut the motifs out of 20-by-30-inch metal sheets, creating a stencil through which the starch is applied.[3]

1. Picton and Mack 1989, p. 157.
2. Stanfield 1971, p. 11.
3. Picton and Mack 1989, p. 155.

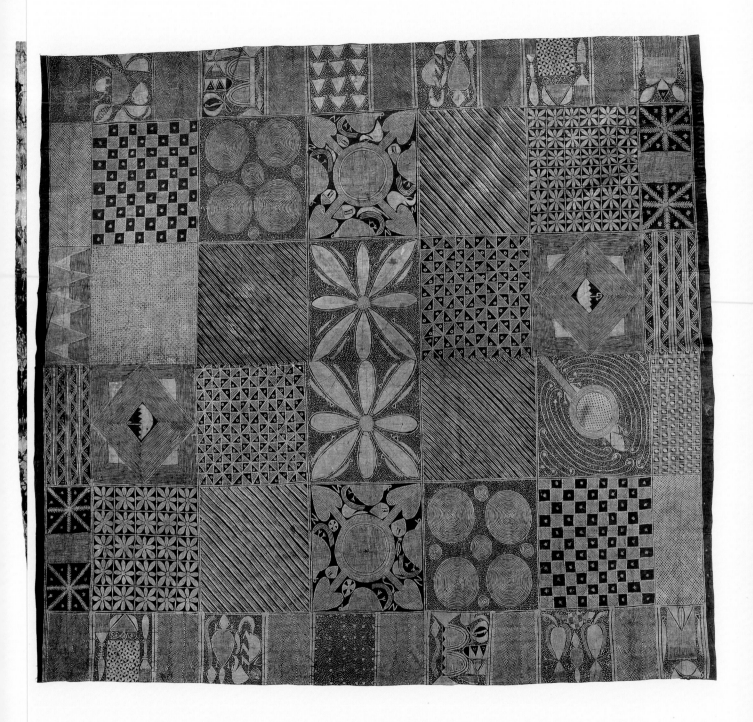

10. Man's wrapper

Nigeria; Yoruba peoples
19th century
Cotton, magenta silk, indigo dye
Warp 70 ⅛ in. (178 cm), weft 44 ⅞ in. (114 cm)
The British Museum, London (Af1934,0307.132)

Provenance: Collected in West Africa between 1880
and 1900 by Charles Beving Sr.; gift of his son to the
British Museum, 1934

The cloth produced by Yoruba men on double-heddle looms has remained a luxury commodity.[1] It is generally woven in strips about 4 inches wide that are cut into lengths and sewn together selvage to selvage to become garments ranging from wraparound cloths to gowns. As is also true of Nupe weavings, a variety of striped patterns, identified by names, emphasize indigo and white stripes.[2]

In this example, the stripes that alternate blue and white were created by a method of resist-dyeing yarns before they are woven that is widely known as ikat. To carry out this technique, the exact amount of warp yarn needed for the ikat-patterned areas must be measured out, held taut, and secured so that it will not shift during subsequent steps in the process. The sections that are to remain white are tightly wrapped and tied in order to resist the dye; then the prepared yarns are dipped in indigo until they reach the desired intensity and allowed to dry before the binding strings are removed. These fibers are then placed onto the loom with other yarns in the order defined by the pattern.

The richly blended magenta and indigo design of this cloth is composed from ten strips of hand-spun silk and cotton. Each contains the same sequence of stripes: a broad indigo-and-white pinstripe alongside an alternation of solid magenta stripes with blue-and-white ikat ones. Despite the regular repetition, however, no two of the ikat-patterned elements are perfectly aligned, and this asymmetry creates a sense of infinite variation.

Silk has a complex history in West Africa. Wild silk harvested in the savannah of northern Nigeria from the cocoons of various species of moth of the genus *Anaphe* is known as *sanyan*. A silk yarn often dyed bright magenta or red, *alharini*, comes from farther afield. As early as the sixth century, this so-called waste silk, a by-product of North Africa's silk industry, was obtained from Tunisia. Beginning in the eleventh century or earlier, it was carried through trade networks from Tripoli to the northern Nigerian market town of Kano. During the nineteenth century, vast quantities of waste silk from French and Italian silk-processing mills were sent to North Africa and there dyed popular colors, such as magenta, not readily available farther south.[4] Magenta silk of this type is present in the wrapper seen here; all the other yarns are cotton.

1. Picton and Mack 1989, p. 108.
2. Ibid., pp. 109, 112.
3. Lamb and Holmes 1980, pp. 39–41.
4. Gilfoy 1987, p. 37.

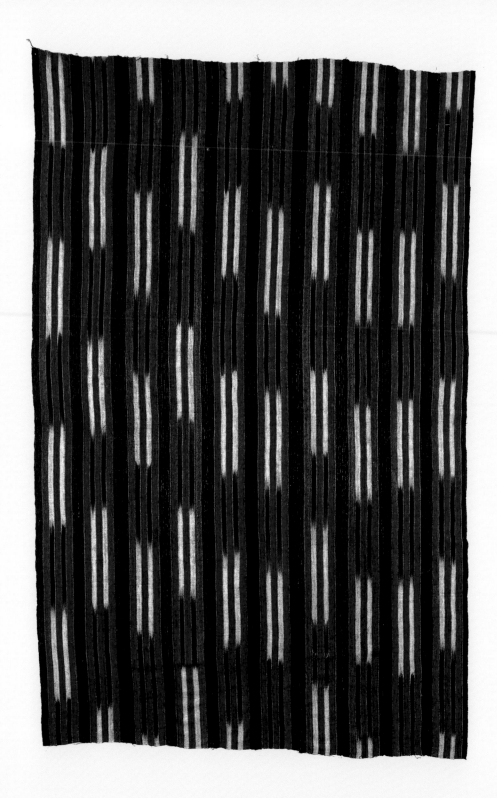

11. Man's protective tunic

Nigeria; Hausa peoples
Late 19th century
Cotton, leather, paper, pigment
H. 35 ⅞ in. (91 cm), W. 34 ⅝ in. (88 cm)
The British Museum, London (Af1940,23.1)

Provenance: Acquired from Captain Alfred Walter
Francis Fuller, 1940

Every inch of this simple cotton tunic was inscribed and invested with prayers by an itinerant Hausa artist who sought to transform it into a mantle of invulnerability. The extraordinary measures taken suggest that the garment was made for an important warrior to wear into battle. The Islamic belief in the power of the Koran's written word is manifested here in a creation configured so its Koranic texts encase the body, affording a line of mystical defense superior to armor.

This exceptional work was acquired by the British Museum in 1940 from Captain Alfred Walter Francis Fuller. Historically such garments were worn by Hausa infantrymen, writes David Heathcote, who in investigating the ideas that informed their creation commissioned a comparable garment in 1971. His experience suggests that the tunic shown here was transformed into an effective prophylactic by three different kinds of alterations. In the first, charm material was prepared for the garment in the form of amulets to be stitched to the inside. These are Koranic texts written out on paper and blessed by Islamic scholars, who then bound them into leather containers. Another measure taken was immersing the tunic in water that had been used to wash Koranic phrases from a writing board. Finally, the surface of the garment was exhaustively inscribed with clearly visible characters that make up a free-form collage of textual passages. Because a warrior's back is particularly vulnerable, the inscriptions are even more densely concentrated across the back of the tunic. In Heathcote's view, the Muslim wearer's faith in the power of these actions rendered the garment effective in protecting him.[1]

The draftsman who undertook such an effort was not a man of learning but an individual gifted in deploying the written word as a form of visual expression. The texts were not intended to be read for their content but rather to be experienced aesthetically as an assault on the gaze effected by their sheer cumulative quantity. The fluidity of these writings on cloth suggests that they may have been a precursor to the embroidery done by Hausa craftsmen.[2]

1. Heathcote 1974, pp. 621–23.
2. Ibid., p. 623.

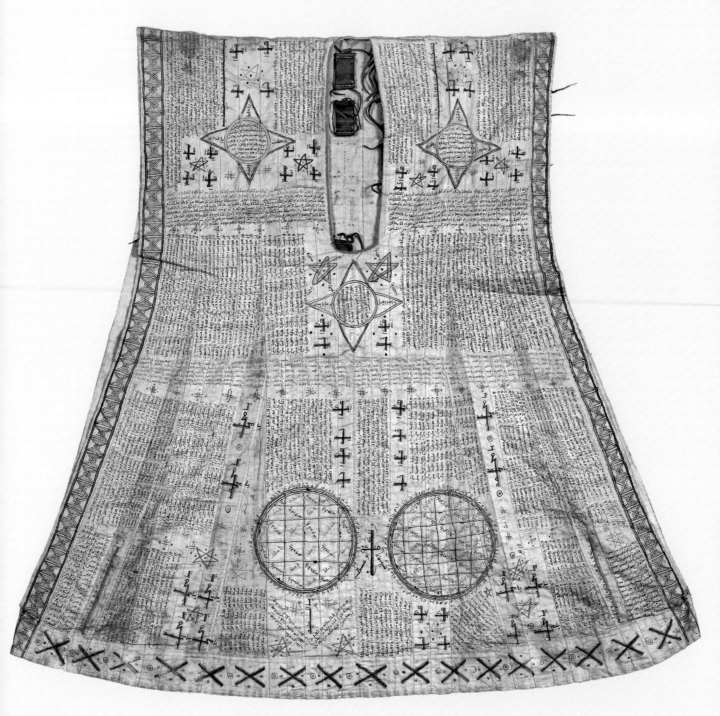

front view

12. Man's robe

Liberia(?); Manding peoples
First half of the 19th century
Cotton, wool, indigo dye
H. 36¼ in. (92 cm), W. 70 ⅞ in. (180 cm)
The British Museum, London (Af.2798)

Provenance: Collected by Henry Christy; his bequest
to the British Museum, 1865

This exquisitely designed and executed man's robe is one regional interpretation of a spectacular fashion worn by elites throughout West Africa. Since the nineteenth century such regal garments have come to be popularly referred to as *boubou*, a French deformation of the Wolof word *mbubb*. The term is generically used to designate any ample garment with long sleeves that can be worn over other clothing.[1] The cut and embroidered ornamentation of Manding examples from Liberia and Sierra Leone suggest that they may have been inspired by Islamic ones from northern Mali.[2] This classic cotton gown with wool accents is configured as a simple rectangle with an opening at the neck and slits at the sides. Its sense of breadth is enhanced by the cloth's bold alternation of light blue and indigo bands extending from one side to the other. That expanse is composed of fifteen narrow strips woven from hand-spun cotton on a man's double-heddle loom. Two different loom strips were used to produce these: one for the six light blue bands, each approximately 4⅛ inches wide, and another for the dark blue ones, which are 5⅛ inches wide. The assembled cloth was folded in half and the sides seamed together from midpoint to bottom, leaving a large aperture for the arms. The neck opening is cut into the cloth. When the garment is put on, its lateral ends drape down elegantly from the wearer's shoulders. The Manding *boubou* has a relatively short cut and is worn over other garments.

The woven field's symmetry is dramatically interrupted by extensive passages of vivid red embroidery that accentuate the neckline and reach downward to cover the area of the chest. Much of this decoration has been added to a woven rectangular "pocket" affixed to the base of the neck opening and extending onto the proper left side of the garment. It is richly articulated with cotton and wool in running stitches and chain stitches. Many of the pectoral designs that enhance such garments were embroidered interpretations of the calligraphic amulets and esoteric drawings found in Islamic prayer books and healing texts. Three horizontal bands of white embroidery extend the width of the garment, accentuating its lower edge and interrupting the pronounced vertical emphasis of the composition.

The scarce surviving documentation for the use of such elaborate early Liberian creations suggests that they were worn by chiefs.[3]

1. Gardi 2000, p. 10.
2. Ibid., p. 124.
3. Ibid., p. 125.

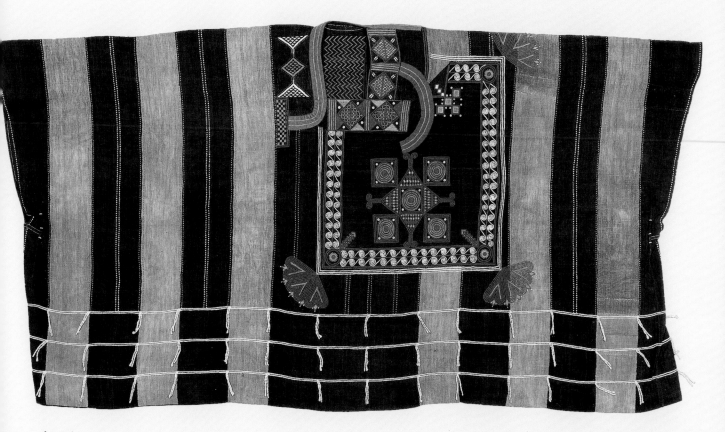

front view

13. Man's gown

Nigeria; Nupe or Hausa peoples
19th century
Cotton, red and undyed silk, indigo dye
H. 54 in. (137.2 cm), W. 99¼ in. (252 cm)
The British Museum, London (Af1920,0211.1)

Provenance: Offered by the king of Dahomey to the British Vice-Admiral Eardley Wilmot between 1863 and 1866; purchased by the British Museum, 1920

Impressive for their lavish use of costly hand-woven fabric and virtuoso embroidery, garments of this kind established their wearer's status, taste, and identification with Islam. In the early 1800s, the reputation of the Nupe as remarkable weavers and producers of such princely gowns, based on the Hausa flowing robe type known as a *riga*, was established throughout Nigeria.[1]

The most renowned exports from the regional center of Egga on the Niger River, which served Nupe, Hausa, and Yoruba peoples, were gowns like this one featuring luxury materials such as indigenous silk or dyed silk imported from North Africa. These elaborate garments were, variously, purchased by aristocratic Fulani, Nupe, and Hausa patrons; used as tributary payments; and traded to the commercial city of Kano for distribution to other Islamic centers. In the nineteenth century such garments clearly distinguished the elite of the northern Nigerian emirates from commoners and could only be acquired through inheritance or the award of a title.[2] This example in the possession of the king of Dahomey in neighboring Benin was presented as a form of tribute to the British Vice-Admiral Eardley Wilmot between 1863 and 1866. In the early twentieth century gowns of this type became widely available commodities. Ironically, as traditional weaving has more recently declined in the face of competition with manufactured cloth, they are once again sought out by the elite.

The aesthetic of Nupe textiles reflects a blending of influences from Hausa and Yoruba neighbors. Decorative patterns are usually restricted to an arrangement of warp-faced longitudinal stripes. The cloth is woven on a double-heddle loom in strips 2½ inches wide that are sold in rolls; from these a wider piece of cloth can be assembled. Made of red-and-white striped silk and cotton, the gown shown here is of the *barage girke* type, a term that identifies both the striped red-and-white silk and cotton cloth from which it is composed and the garment's intermediate status in size and importance. Gowns of this fabric were among the most esteemed and costly large robes produced. This example follows traditional construction methods with the pinstripe extending vertically down the length of the torso but horizontally along the sleeves, introducing an element of contrast into the balanced design.

In northern Nigeria colors in the red family are considered auspicious and endowed with apotropaic properties—here enhanced by the extensive passage of silk embroidery extending across the chest and back. Among the Nupe, embroidery probably dates to the eighteenth century, when Nupe royalty first adopted Islam. Fluid compositions such as this were drawn onto the cloth by Islamic scholars, then stitched by embroidery specialists. Judith Perani suggests that embellishment with graphic motifs derived from Arabic script was intended to bring the

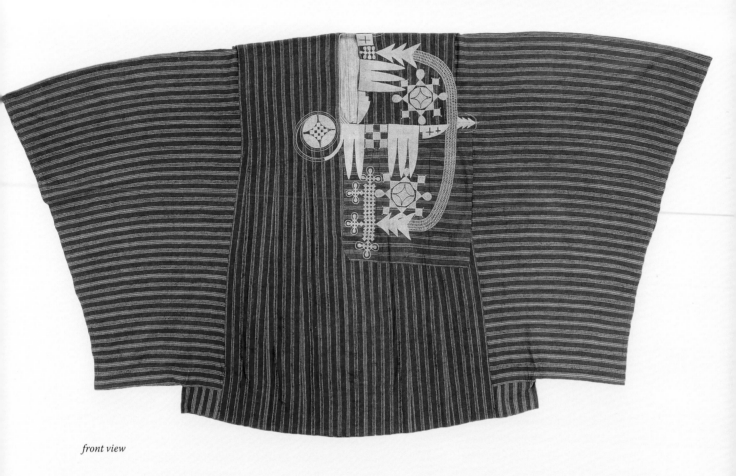

front view

garment's surface under control in order to afford the wearer protective power.[3] In this lavish example, designs associated with protection and chieftancy include the "eight knives" pattern of long triangular elements arranged in groups of two and three; a stylized eight-pointed star; and the *tambari*, or king's drum, shown as a crossed circle in a spiral.[4]

1. Perani 1979, p. 54.
2. Ibid.
3. Ibid., p. 55.
4. Spring and Hudson 2002, pp. 64–67.

14. Woman's wrapper

Nigeria, Akwete; Igbo peoples
Second half of the 19th century
Cotton, synthetic dye
Warp 66⅞ in. (170 cm), weft 28¾ in. (73 cm)
The British Museum, London (Af1934,0307.116)

Provenance: Collected in West Africa between 1880
and 1900 by Charles Beving Sr.; gift of his son to the
British Museum, 1934

The complex stripe motifs at the edges of this panel exactingly frame a field containing a graceful, seemingly random arrangement of formal elements. Woven as an integral unit on a vertical single-heddle loom with a continuous warp, this work comes out of an influential tradition of textiles produced and traded by Igbo female weavers and centered in the town of Akwete in southeastern Nigeria.[1] Akwete textiles are distinctive for their breadth, which dramatically contrasts with the considerably narrower 8-to-24-inch width of strips produced by female weavers elsewhere in the region (the present cloth is atypical, an especially narrow example of the genre). In Akwete all women are expected to know how to weave from an early age, and most of them do so as full-time professionals. Over the course of a month, an Akwete weaver may produce as many as four cloths. The work is in great demand and is disseminated to a widespread assortment of regional patrons of other ethnicities.[2]

Akwete women take pride in their continual expansion of the repertory of designs. The premium placed on imaginative innovation is reflected in the frequent citing of dreams as the source of inspiration for new ideas woven into cloth. At the same time, the weavers' technical skill is such that they have embraced the challenge of replicating formal features of textile designs introduced from the outside, such as Indian madras and Ewe weaving. The design principle apparent in this nineteenth-century

work, a solid-colored background animated with a repeated motif, continues to be followed by contemporary Akwete weavers. While in this instance the element that appears against the salmon field is a parallelogram, in others it may be a flower, flag, bird, or cluster of animals.[3] These supplementary patterns are woven so that they protrude from the plain-weave ground, an effect achieved by using a thick supplementary-weft yarn for the patterns and binding it down with every sixth warp thread. Commercially prepared yarns and synthetic dyes were employed in making the work. The use of a pronounced yellow both in the striated framing device and on some of the design elements within unifies the composition.

While the parallelogram motifs at first glance appear free-floating, more careful examination reveals that they are arranged in alternating tiers of three and two. Unlike the wrappers produced on a man's loom that require the joining of many strips to form the finished textile, this work was complete when it was removed from the loom. Yet despite the breadth of format afforded by Akwete weaving, its formal elaboration remains faithful to the sensibility of design structured in alternating bands.

1. Aronson 1980, p. 65.
2. Ibid., pp. 65, 62.
3. Ibid., p. 66.

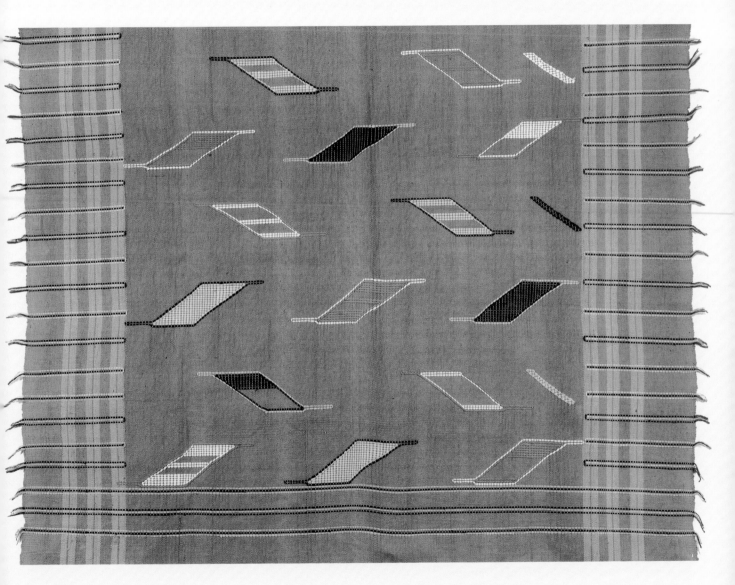

partial view

15. Woman's wrapper

Western Nigeria, northern Togo, or Republic of Benin
20th century
Cotton, indigo dye
Warp 72 in. (182.9 cm), weft 55 in. (139.7 cm)
The Metropolitan Museum of Art, New York; Purchase,
Fred and Rita Richman Foundation Gift, 2007 (2007.230)

Provenance: Purchased in New York from an African
collector, ca. 2005; purchased by the Metropolitan
Museum, 2007

The width of the two openwork panels that make up the major part of this cloth indicates that they were woven by a woman on a vertical single-heddle loom. Formerly this type of loom was used by weavers in an area extending from Togo through Nigeria to western Cameroon. At present it continues to be used among the Yoruba, the various Ede-speaking peoples, the Ebira, the Nupe, the Hausa, and the Igbo.[1] The cloth produced on such a loom may be woven in a single color or with a large number of variations of warp striping. Patterning may also be added through supplementary wefts, or bands of float weave or openwork may be deployed. The transformative procedure of indigo dyeing is another means of enhancing a cloth's visual appeal. Since documented examples with similar openwork are undyed, it is possible that this cloth was woven in one area and subsequently dyed by specialists in one of the Nigerian centers known for indigo dyeing.

In contrast to cloths woven by men, those woven by their female counterparts are never tailored. In the present age, handwoven textiles and industrially produced wax prints are both essential parts of a woman's dress and are commonly worn together. They are layered, with the largest textile wrapped around the lower body and partially covered by an outer cloth. Because of its transparency, this work is likely to have served as an outer accent of this type.

Rather than fill a field with design, the author of this work articulated her vision by accentuating negative space. This openwork pattern was created on a warp-face plain-weave fabric by using extra wefts to bind groups of warp elements together into columns of six or ten yarns. Each column has its own weft yarns, which are cut at either side of the column and begun anew for the next column.

The wrapper is composed of five individual pieces of cotton cloth and an added fringe. The largest components are the two vertical panels, each a loom width, approximately 24 inches. It is likely that they were woven in one single length, since the yarn quality and weaving are identical. Each panel is joined along one selvage to a narrow strip of factory-woven cloth that runs down the center of the wrapper. At both warp ends a narrow woven and knotted band was added. The deep color and overall evenness of the dye on the various differently surfaced fabrics suggests that they were first woven, then pieced together, and last indigo-dyed.

1. Clarke 2001, p. 107, and Duncan Clarke, personal communication with the authors, July 2008.

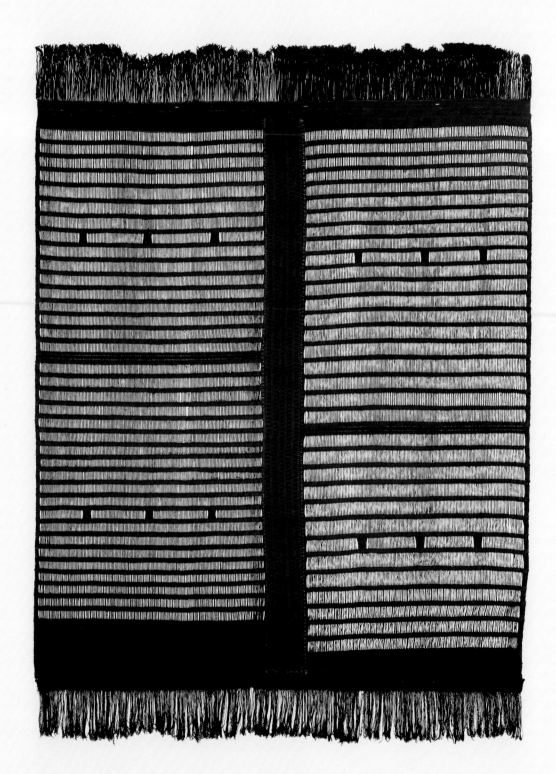

16. *Between Earth and Heaven*

El Anatsui (Ghanaian, b. 1944)
2006
Aluminum, copper wire
H. 86¾ in. (220.3 cm), W. 10 ft. 8 in. (320 cm)
The Metropolitan Museum of Art, New York; Purchase,
Fred M. and Rita Richman, Noah-Sadie K. Wachtel
Foundation Inc., David and Holly Ross, Doreen and
Gilbert Bassin Family Foundation and William B.
Goldstein Gifts, 2007 (2007.96)

This alluring object defies facile categorization.
It belongs to a genre, invented by El Anatsui in
the late 1990s, of works that have variously been
described as metal cloth and as tapestry. Thou-
sands of pieces from discarded aluminum caps
of liquor bottles were flattened, sorted by color,
and then stitched together with copper wire into
this overarching composition. The completed
canvas has a malleability that the artist subse-
quently exploited, impressing creases and folds
into the surface to endow it with an animate,
billowing quality.

These pliable constructions subvert the notion
of metal as stiff and unyielding and offer seem-
ingly endless possibilities for reshaping and
reconfiguring. When it was completed in
Nsukka, Nigeria, this example was exhibited
outdoors in the form of a luminous freestanding
sculpture. Since its current installation at The
Metropolitan Museum of Art, which was over-
seen by the artist on January 6, 2008, it has
appeared as a resplendent and animated tapestry
expanding outward from the gallery wall on
which it hangs. The viewer's physical position in
relation to the work is yet another aspect of its
contingency. The farther away one stands, the
more the various tonalities blend together; the
closer one's view, the more clearly the compo-
nent elements can be read as discrete units.

The surface has a reflective radiance that sug-
gests the opulence of Asante and Ewe *kente* cloth.

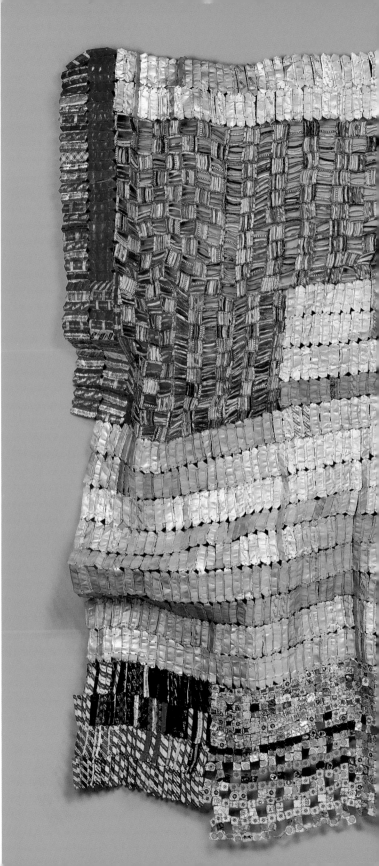

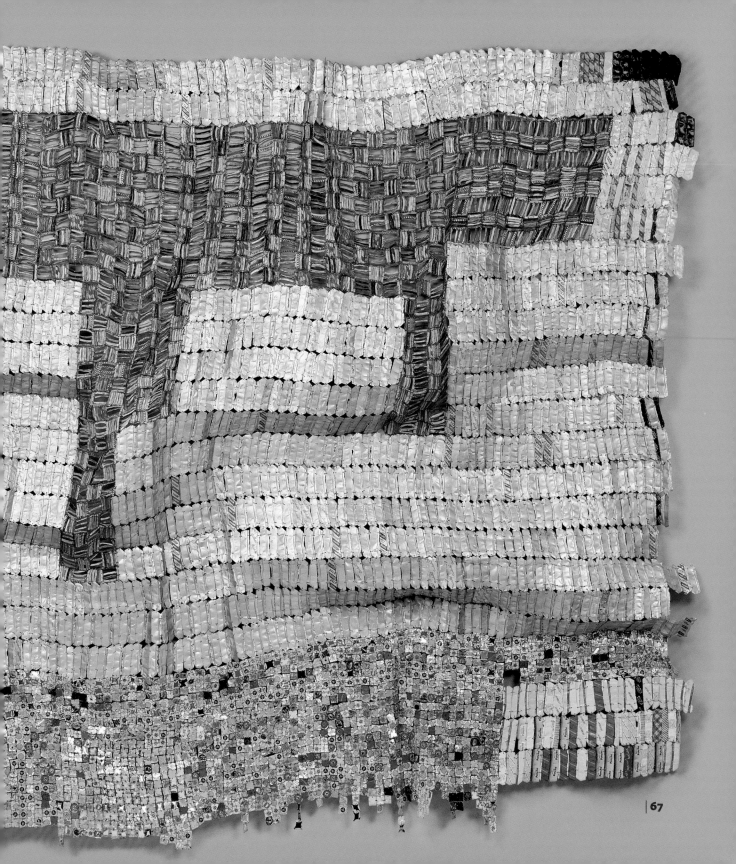

Venice Lamb notes that gold tones in *kente* are an attribute of chieftaincy and that their use "denotes warmth, long life, prosperity."[1] In *Between Earth and Heaven,* the predominant gold foil represents an elevation of the most mundane detritus to an exalted state by its artistic transformation and, simultaneously, alludes to the precious mineral resource exported from the Gold Coast to the world at large. The same trade networks that were developed to exploit West Africa's gold eventually shifted focus to trade in slaves. In exchange for these exports, commodities such as textiles and liquor were brought into the region. All these associations converge in *Between Earth and Heaven,* whose otherworldly resplendence is tempered by allusions to human shortcomings. The sheen of the costly silk threads obtained by unraveling imported fabrics and incorporated into new *kente* textiles at the beginning of the eighteenth century is here formally evoked by the work's luster and its passages of multicolored weave. The alcoholic spirits poured as libations honoring ancestors and also consumed in large quantities are concretely manifest in this work, which is composed of bottle caps discarded by a single community.

Anatsui is a contemporary master who has mined his landscape for locally available materials and idioms of expression and then transposed them into personal creations with an entirely new syntax. Raised in an Ewe-speaking area of southern Ghana, he studied sculpture and art education at the University of Science and Technology, Kumasi, receiving an academic training that emphasized Western art practice. As a counterbalance he expanded his artistic formation by observing the creative processes of traditional weavers, *adinkra* cloth printers, potters, and sculptors. Early in his career Anatsui embraced a visual language drawn from the colors and patterns of Ewe and Asante strip weaving and of *adinkra* motifs.[2] A member of the faculty of the Department of Fine and Applied Art at the University of Nigeria, Nsukka, since 1975, Anatsui has continued to adapt aspects of vernacular visual systems into his own artistic vocabulary. Through its formal qualities, *Between Earth and Heaven* pays tribute to the vital aesthetic of West Africa's legacy of strip-woven textiles and reflects upon the often-wrapped, sculptural nature of cloth. Anatsui's seemingly alchemical transformation of base metal is fresh, utterly original, and contemporary; at the same time, he is conversant with the vibrant legacy of regional textile traditions that go back a millennium and retain their profound cultural significance.

1. Lamb 1975, p. 141.
2. Péri-Willis 1998, pp. 80–81.

Bibliography

Aronson 1980
Lisa Aronson. "Patronage and Akwete Weaving." *African Arts* 13 (May 1980), pp. 62–66.

Aronson 1982
Lisa Aronson. "Popo Weaving: The Dynamics of Trade in Southeastern Nigeria." *African Arts* 15 (May 1982), pp. 43–47.

Baldwin 1979
Hannah Baldwin. "The Embroidery-Resist Cloth of Senegal: A Search for Origins." Unpublished paper, 1979.

Balfour-Paul 1999
Jenny Balfour-Paul. "Muddy River Blues." *Hali* 105 (July–August 1999), pp. 88–93.

Balfour-Paul 2006
Jenny Balfour-Paul. *Indigo.* Archetype Publications, 2006.

Bolland 1991
Rita Bolland. *Tellem Textiles : Archaeological Finds from Burial Caves in Mali's Bandiagara Cliff.* Mededelingen van het Rijksmuseum voor Volkenkunde, Leiden, no. 27. Amsterdam: Tropenmuseum/Royal Tropical Institute, 1991.

Boser-Sarivaxévanis 1969
Renée Boser-Sarivaxévanis. *Aperçus sur la teinture à l'indigo en Afrique Occidentale.* Basel, 1969.

Boser-Sarivaxévanis 1972
Renée Boser-Sarivaxévanis. *Les Tissus de l'Afrique Occidentale.* Basler Beiträge zur Ethnologie, vol. 13. Basel: Pharos-Verlag Hansrudolf Schwabe, 1972.

Clarke 1997
Duncan Clarke. *The Art of African Textiles.* San Diego: Thunder Bay Press, 1997.

Clarke 2001
Duncan Clarke. "Money Is the Cloth of Fashion: Textiles from the Yoruba Region of Nigeria." *Hali* 118 (September–October 2001), pp. 106–12.

Cole and Ross 1977
Herbert M. Cole and Doran H. Ross. *The Arts of Ghana.* Exh. cat., Frederick S. Wight Gallery, University of California, Los Angeles; Walker Art Center, Minneapolis; Dallas Museum of Fine Arts. Los Angeles: Museum of Cultural History, University of California, 1977.

Crow 1830
Hugh Crow, *Memoirs of the Late Captain Hugh Crow of Liverpool.* 1st ed. 1830. London: Frank Cass Publishers, 1970.

De Negri 1966
Eve De Negri. "Nigerian Textile Industry before Independence." *Nigeria Magazine,* no. 89 (1966), pp. 95–101.

Emery 1966
Irene Emery. *The Primary Structures of Fabrics.* Washington, D.C.: Textile Museum, 1966.

Gardi 1985
Bernhard Gardi. *Ein Markt wie Mopti: Handwerkerkasten und traditionelle Techniken in Mali.* Basel: Ethnologisches Seminar der Universität und Museum für Völkerkunde/Wepf, 1985.

Gardi 2000
Bernhard Gardi. *Le Boubou—c'est chic: Les Boubous du Mali et d'autres pays de l'Afrique de l'Ouest.* Exh. cat., Museum der Kulturen Basel. Basel: Christoph Merian, 2000.

Gilfoy 1987
Peggy Stoltz Gilfoy. *Patterns of Life: West African Strip-Weaving Traditions.* Washington, D.C.: Smithsonian Institution Press/National Museum of African Arts, 1987.

Heathcote 1974
David Heathcote. "A Hausa Charm Gown." *Man,* n.s. vol. 9, no. 4 (December 1974), pp. 620–24.

Hynes and Picton 2001
Nancy Hynes and John Picton. "Yinka Shonibare." *African Arts* 34, no. 3 (Autumn 2001), pp.60–73. [Hynes, "Re-Dressing History," pp. 60–65; Picton, "Undressing Ethnicity," pp. 66–73.]

Imperato 1973
Pascal James Imperato. "Wool Blankets of the Peul of Mali." *African Arts* 6 (Spring 1973), pp. 40–84.

Imperato 1976
Pascal James Imperato. "Kereka Blankets of the Peul." *African Arts* 9 (July 1976), pp. 56–59, notes continued on p. 92.

Kumasi Junction **2002**
Kumasi Junction. Exh. cat., Oriel Mostyn Gallery, Llandudno, Wales, 2002.

Lamb 1975
Venice Lamb. *West African Weaving.* London: Duckworth, 1975.

Lamb and Holmes 1980
Venice Lamb and Judy Holmes. *Nigerian Weaving.* Hertingfordbury: Roxford, 1980.

Lamb and Lamb 1984
Venice and Alastair Lamb. *Sierra Leone Weaving.* Hertingfordbury: Roxford, 1984.

McNaughton 1982
Patrick R. McNaughton. "The Shirts that Mande Hunters Wear." *African Arts* 15 (May 1982), pp. 54–58.

Nielsen 1979
Ruth Nielsen. "The History and Development of Wax-Printed Textiles Intended for West Africa and Zaire." In Justine M. Cordwell and Ronald A. Schwarz, eds., *The Fabrics of Culture: The Anthropology of Clothing and Adornment.* The Hague/Paris/New York: Mouton, 1979, pp. 467–98.

Perani 1979
Judith Perani. "Nupe Costume Crafts." *African Arts* 12 (May 1979), pp. 52–57.

Perani and Wolff 1999
Judith Perani and Norma H. Wolff. *Cloth, Dress and Art Patronage in Africa.* Oxford and New York: Berg, 1999.

Péri-Willis 1998
Elizabeth A. Péri-Willis. "Chambers of Memory." In John Picton et al., *El Anatsui: A Sculpted History of Africa.* London: Saffron Books/October Gallery, 1998, pp. 79–88.

Picton 1992
John Picton. "Tradition, Technology and Lurex: Some Comments on Textile History and Design in West Africa." In *History, Design, and Craft in West African Strip-Woven Cloth.* Papers presented at a symposium organized by the National Museum of African Art, Smithsonian Institution, February 18–19, 1988. Washington, D.C., 1992, pp. 13–52.

Picton 1995
John Picton et al. *The Art of African Textiles: Technology, Tradition and Lurex.* London: Barbicon Art Gallery/Lund Humphries, 1995.

Picton and Mack 1979
John Picton and John Mack. *African Textiles: Looms, Weaving and Design.* London: British Museum Publications for the Trustees of the British Museum, 1979.

Picton and Mack 1989
John Picton and John Mack. *African Textiles.* New York: Harper & Row, 1989.

Pitts 1978
Delia Carol Pitts. "An Economic and Social History of Cloth Production in Senegambia." Ph.D. diss., University of Chicago, 1978.

Polakoff 1982
Claire Polakoff. *African Textiles and Dyeing Techniques.* London and Henley: Routledge & Kegan Paul, 1982.

Posnansky 1992
Merrick Posnansky. "Traditional Cloth from the Ewe Heartland." In *History, Design, and Craft in West African Strip-Woven Cloth.* Papers presented at a symposium organized by the National Museum of African Art, Smithsonian Institution, February 18–19, 1988. Washington, D.C., 1992, pp. 113–32.

Rattray 1927
Rattray, R. S. [Robert Sutherland]. *Religion and Art in Ashanti.* London: Clarendon, 1927. Reprint Oxford University Press, 1959.

Ross 1998
Doran H. Ross et al. *Wrapped in Pride: Ghanaian Kente and African American Identity.* Los Angeles: UCLA Fowler Museum of Cultural History, 1998.

Schaedler 1987
Karl-Ferdinand Schaedler. *Weaving in Africa South of the Sahara.* Munich: Panterra, 1987.

Sieber 1972
Roy Sieber. *African Textiles and Decorative Arts.* Exh. cat., Museum of Modern Art, New York; Los Angeles County Museum of Art; M. H. de Young Memorial Museum; Cleveland Museum of Art. New York: Museum of Modern Art, 1972.

Spring and Hudson 2002
Chris Spring and Julie Hudson. *Silk in Africa.* Seattle: University of Washington Press, 2002.

Stanfield 1971
Nancy Stanfield et al. *Adire Cloth in Nigeria: The Preparation and Dyeing of Indigo Patterned Cloths among the Yoruba.* Jane Barbour and Doig Simmonds, eds. Ibadan: Institute of African Studies, University of Ibadan, 1971.

Steiner 1985
Christopher B. Steiner. "Another Image of Africa: Toward an Ethnohistory of European Cloth Marketed in West Africa, 1873–1960." *Ethnohistory* 32, no. 2 (Spring 1985), pp. 91–110.

Wadsworth and Mann 1931
Alfred P. Wadsworth and Julia de Lacy Mann. *The Cotton Trade and Industrial Lancashire, 1600–1780.* Manchester University Press, 1931.

Warmington 1969
B. H. [Brian Herbert] Warmington. *Carthage.* New York: Frederick A. Praeger, rev ed. 1969.

Index

Photograph Credits